INSIDE
THE GETTY

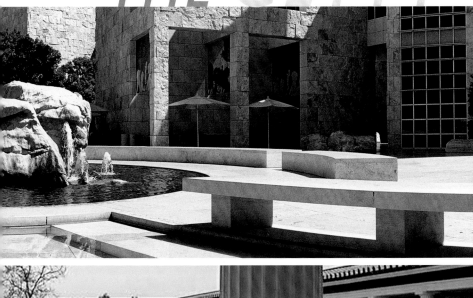

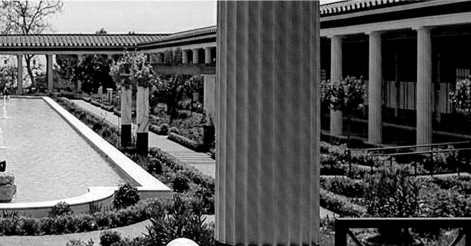

Edited by William Hackman and Mark Greenberg

*Special photography by Richard Ross
and Getty staff photographers*

THE J. PAUL GETTY TRUST
LOS ANGELES

*This book is dedicated to the staff, docents, and volunteers—
both past and present—of the J. Paul Getty Trust.*

© 2008 J. Paul Getty Trust

**Published by the J. Paul Getty Trust,
Los Angeles**
Getty Publications
1200 Getty Center Drive, Suite 500
Los Angeles, California 90049-1682
www.getty.edu/publications

Gregory M. Britton, *Publisher*
Mark Greenberg, *Editor in Chief*

Patrick E. Pardo, *Project Editor*
Gregory A. Dobie, *Copy Editor*
Jim Drobka, *Designer*
Elizabeth Zozom, *Production Coordinator*
Elizabeth Chapin Kahn, *Photo Researcher*
Color separations by Professional Graphics
 Inc., Rockford, Illinois
Printed in Singapore by Tien Wah Press
 (Pte) Limited

Front cover: The Getty Research Institute
at the Getty Center with the Pacific Ocean
beyond.

Back cover: A scientist from the Getty
Conservation Institute examines Edgar
Degas' painting *The Milliners*.

Half-title page: The Central Garden at the
Getty Center (top) and the Museum and
Outer Peristyle at the Getty Villa (bottom).

Title page: The boulder fountain in the
Museum Courtyard at the Getty Center
(top) and the large pool and gardens of the
Outer Peristyle at the Getty Villa (bottom).

Page vi: The azalea maze in the Central
Garden at the Getty Center.

Page vii: The Barbara and Lawrence
Fleischman Theater at the Getty Villa.

Principal photography for this book was
undertaken by Richard Ross with additional
site photography by the Getty's Imaging
Services photographers. See page 178 for
complete credit information.

Any unacknowledged claimants should
notify the publisher for recognition in
future editions.

Library of Congress Control Number:
2007938936

ISBN: 978-0-89236-911-9

Editors' Note: The text for this book
draws upon numerous sources, includ-
ing *The J. Paul Getty Museum and Its Col-
lections*, *Guide to the Getty Villa*, *Making
Architecture*, and *The J. Paul Getty Museum
Handbook of the Collections*, as well
as Getty Trust annual reports, newsletters,
and interviews with current and former
Getty staff.

FSC
Mixed Sources
Product group from well-managed
forests, controlled sources and
recycled wood or fibre
Cert no. DNV-COC-000025
www.fsc.org
© 1996 Forest Stewardship Council

INSIDE THE **GETTY**

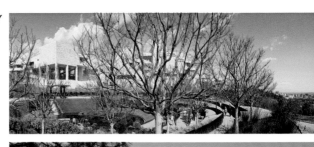

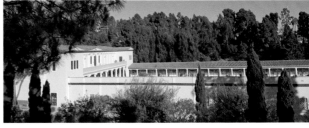

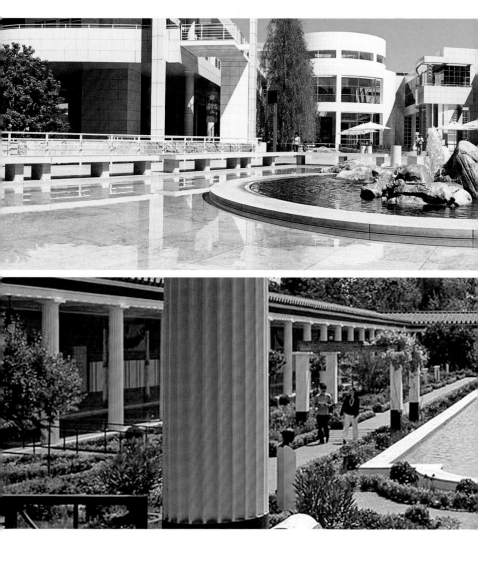

CONTENTS

FOREWORD

In 1954 J. Paul Getty opened to the public a museum of art in a few rooms in his Spanish-style house overlooking the Pacific Ocean near Malibu. His modest collection consisted of Greek and Roman antiquities, Renaissance and Baroque paintings, and eighteenth-century French decorative arts. Today, the educational trust that bears his name is one of the largest art organizations in the world. It encompasses two campuses, each with a museum; four operating programs; and enormous holdings of art and research materials. The story of the approximately fifty intervening years is one of almost constant change.

In 1957 Getty added gallery space to his house to accommodate his growing collection. In the late 1960s he decided to re-create on the property a Roman villa complete with a new museum building, which opened to the public in 1974. His death two years later and the bequest of his fortune to the Museum allowed for the operations and facilities to be significantly expanded. In 1981 the trust's legal name was changed from the J. Paul Getty Museum to the J. Paul Getty Trust. New programs were created throughout the 1980s, the Getty Center was built in the 1990s, and the renovated Getty Villa opened in 2006.

As we have just marked the tenth anniversary of the Getty Center, it is appropriate to reflect on the accelerated history of the Getty Trust and to celebrate J. Paul Getty's gift. His simple wish was to promote "the diffusion of artistic and general knowledge," which the Trust strives to do through its facilities and programs. The present mission statement indicates the ambitiousness of the task:

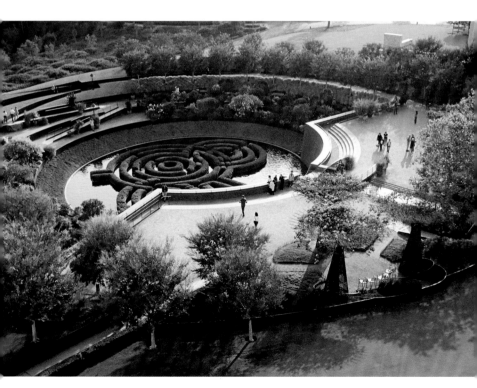

The J. Paul Getty Trust is an international cultural and philanthropic institution that focuses on the visual arts in all their dimensions, recognizing their capacity to inspire and strengthen humanistic values. The Getty serves both the general public and a wide range of professional communities in Los Angeles and throughout the world. Through the work of the four Getty programs—the Museum, Research Institute, Conservation Institute, and Foundation—the Getty aims to further knowledge and nurture critical seeing through the growth and presentation of its collections and by advancing the understanding and preservation of the world's artistic heritage. The Getty pursues this mission with the conviction that cultural awareness, creativity, and aesthetic enjoyment are essential to a vital and civil society.

This unique volume provides in words and pictures an overview of the Getty Trust, an explanation of its activities, and a behind-the-scenes look at how the organization functions from day to day. The book was prepared by William Hackman and the project staff at Getty Publications and was immeasurably enlivened by the remarkable photographs of Richard Ross and the Getty's Imaging Services photographers. We invite the reader to take a tour inside this institution in order to learn more about its buildings, grounds, art, archival resources, and worldwide programs, all of which grew out of the "museum, gallery of art and library" that J. Paul Getty created a little more than a half century ago.

James Wood
President and Chief Executive Officer
The J. Paul Getty Trust

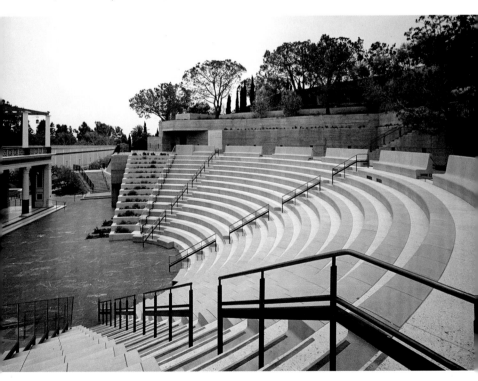

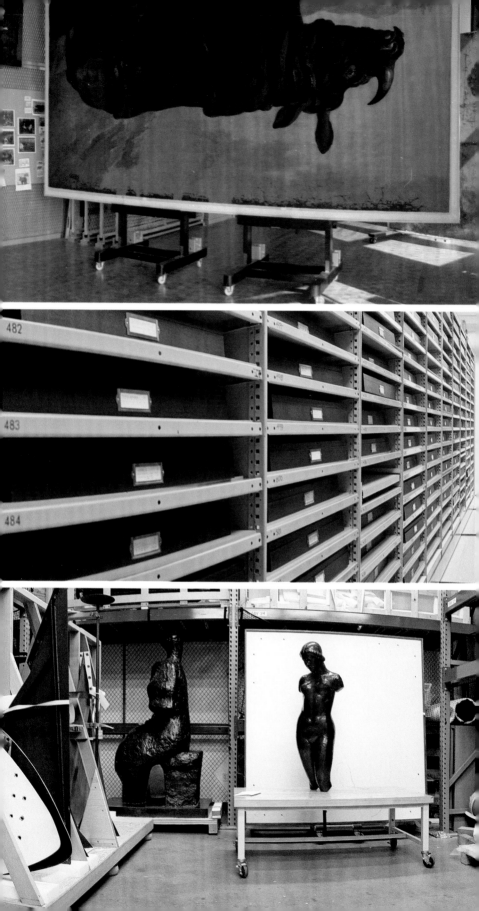

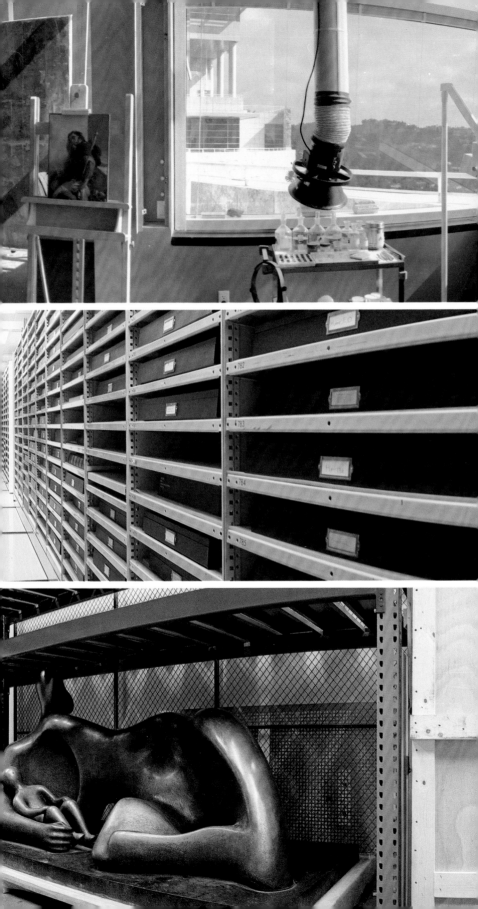

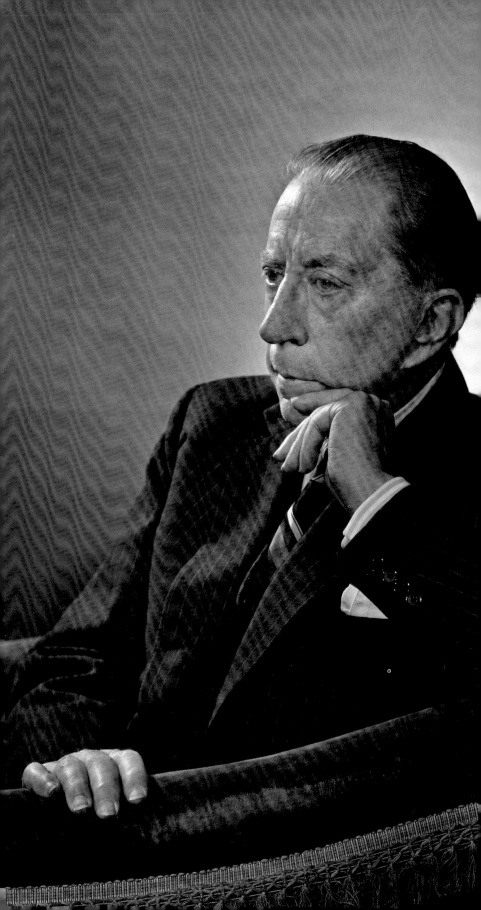

1 A Short History of the J. Paul Getty Trust

THE ORIGINS OF THE J. PAUL GETTY Trust date to 1953 and J. Paul Getty's decision to open a small, private museum in the house he had purchased eight years earlier near Malibu, California. For much of his adult life, Getty was known as the "richest living American," a title bestowed on him more or less officially by *Fortune* magazine in 1957. It was not a rags-to-riches story; J. Paul Getty was born in 1892 to an affluent oil wildcatter and eventually took over his father's business, Getty Oil. At the age of twenty-one, Getty set up shop in Tulsa, Oklahoma; by the time he was

twenty-four, he had parlayed an initial investment of five hundred dollars into his first million. In the following years he would move from the ranks of the merely rich to the fabulously wealthy.

As an oilman, Getty had thought big almost from the start; as a collector of art, he had more modest ambitions. His first great coup came in 1938. In addition to having assembled a group of extraordinary pieces of French furniture, he bought a portrait by Rembrandt and the so-called Ardabil Carpet. Getty's other chief interest at the time was antiquities. His most significant purchase in that area was in 1951 with the acquisition of the Lansdowne Herakles, a Roman statue in marble modeled after a Greek original. He bought what interested him. "Few human activities," he remarked, "provide an individual with a greater sense of personal gratification than the assembling of a collection of art objects that appeal to him and that he feels have a true and lasting beauty."

When, in 1945, a parcel of sixty-four acres became available in a canyon at the border of Los Angeles and Malibu, Getty

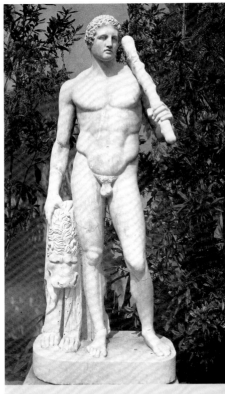

The Lansdowne Herakles, one of Getty's favorite works of art, was first displayed outdoors in a courtyard of the Ranch House.

Portrait of J. Paul Getty (left) by Yousuf Karsh, 1965. Detail from a portrait painting of Getty (inset, top) by Gerald L. Brockhurst, 1938.

J. Paul Getty in the mid-1960s at Sutton Place, his English estate, purchased in 1959.

grabbed it. The property included a Spanish-style residence, referred to by Getty as the Ranch House, in which he installed his art collection.

In 1951 Getty left the United States for Europe to be nearer his business interests in the Middle East. Norris Bramlett, one of his closest advisers in Los Angeles, suggested that he open the Ranch House to the public as a museum. Getty agreed, and in 1954 the J. Paul Getty Museum opened. A year before, Getty had formed an educational trust, administered by a board of trustees, that would oversee his art collection. Although he always said he intended to return to his native country, he never did, and thus never saw the museum that bore his name.

In 1968 Getty decided to build a Roman-style villa on the site near Malibu to house his expanding art collection, and six years later the new J. Paul Getty Museum (later referred to simply as the Getty Villa) welcomed its first visitor.

Although his devotion to art was deeply felt, Getty publicly stated on several occasions that he intended to leave little of his fortune to his museum—an endowment sufficient for operating expenses but little more. It came as a great surprise to everyone, therefore, when, following the oil billionaire's death in 1976, it was announced that he had in fact bequeathed the bulk of his estate to the Museum. The institution received four million shares of Getty Oil stock, then worth seven hundred million dollars. Overnight the Getty was transformed from a small, specialized institution hidden away in a canyon, better known for its replica of a classical building than for its collection, to the richest museum in the world.

This unexpected windfall marked a true turning point for the Museum and its trustees. The bequest came with no strings attached. Getty provided few instructions or restrictions on how the money should be spent. He had executed a trust indenture in late 1953, but it simply authorized the creation of a "museum, gallery of art and library" and stated the purpose of the trust as "the diffusion of artistic and general knowledge." Of course, by 1976 the Getty Villa had already been open for two years and was fulfilling its founder's mission—and would continue to display the collection, mount exhibitions, and develop public programming as Getty's bequest was finalized. Due to a number of complex legal and tax issues, the money left to the Museum was not officially

transferred until the spring of 1982; a year before, the trust's name had been legally changed from the J. Paul Getty Museum to the J. Paul Getty Trust.

Given the magnitude of the endowment and Getty's purpose, the trustees realized that the newly endowed trust should have a greater impact on the visual arts than the Museum alone could. Toward that end, they hired Harold M. Williams to be president and chief executive officer of the Getty Trust. A native of Los Angeles, Williams had previously been chairman of the Securities and Exchange Commission during the administration of President Jimmy Carter. A year later, Williams hired John Walsh to be director of the Museum, succeeding Stephen Garrett.

As could be expected, the years 1982 to 1984 were ones of rapid growth and change. The trustees, together with Williams and his colleagues, formulated a proposal that called for—in addition to an expanded museum—a group of independent but related programs devoted to scholarship, conservation, and education. These programs became the Getty Center for the History of Art and the Humanities (now the Getty Research Institute), the Getty Conservation Institute, the Getty Center for Education in the Arts, the Getty Art History Information Program, and the Getty Grant Program (now the Getty Foundation).

It soon became clear that these new programs, along with the attendant desire for the Museum to collect works in other areas, required a larger, unified facility, a main campus to accommodate what the Trust envisioned for its extended mission. Expanding the Villa site for this purpose was impossible. In 1983, a roughly 750-acre property in Brentwood, in west Los Angeles, was purchased by the Trust, and the following year the architectural firm Richard Meier & Partners was chosen to design the Getty Center, which would house the Trust, its five newly created programs, and a second Museum. After three years of design, discussions, and approvals, construction began in 1987. It took a decade of hard work, planning, and collaboration to realize the opening of the Getty Center in December 1997. The dawn of the Center, undoubtedly a crowning achievement, also marked a coda, at least temporarily, for the Getty Villa.

On July 6, 1997, forty-three years after the original J. Paul Getty Museum had opened in Getty's Ranch House, the Villa closed in anticipation of the Center's opening and in order to undergo an extensive renovation campaign—home improvements, so to speak, albeit on a dramatic scale. These were completed in early 2006, and, on January 28 of that year, the Villa reopened as a museum and educational center dedicated to the arts and cultures of antiquity. Today, the J. Paul Getty Trust encompasses two campuses and oversees four separate but interwoven programs: the J. Paul Getty Museum, the Getty Research Institute, the Getty Conservation Institute, and the Getty Foundation. While the Trust and its programs are headquartered at the Getty Center and are active in Los Angeles and all over the world, each has a physical and spiritual embodiment at the Getty Villa, where the Trust was born.

J. PAUL GETTY SCRAPBOOK

Although J. Paul Getty may have had a reputation for being a bit of a curmudgeon, he did know how to enjoy his life, status, and wealth.

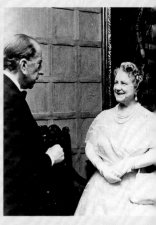

J. Paul Getty with (left to right) Ringo Starr (1965), Zsa Zsa Gabor (1972), and Queen Elizabeth, the Queen Mother (1969).

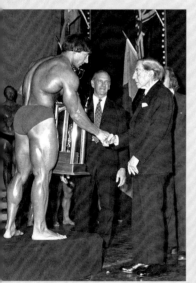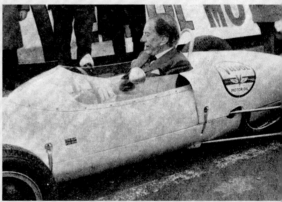

Even at an advanced age, Getty continued to enjoy two unusual passions: competition bodybuilding and auto racing, early 1970s.

J. Paul Getty at Sutton Place doing the twist with children from a church orphan home, 1963.

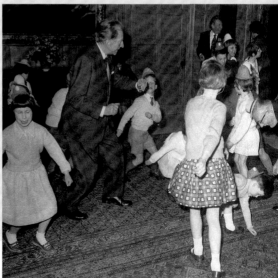

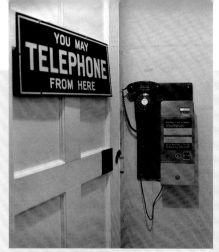

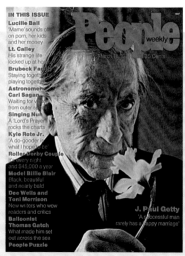

"The world's most famous coin-box tele-phone," as Getty amusingly referred to this pay phone, which he had temporarily installed in a room at Sutton Place to curtail calls made at his—and Getty Oil's—expense. This photo was taken by Julius Shulman in 1964.

J. Paul Getty on the cover of the third issue of *People* magazine in 1974.

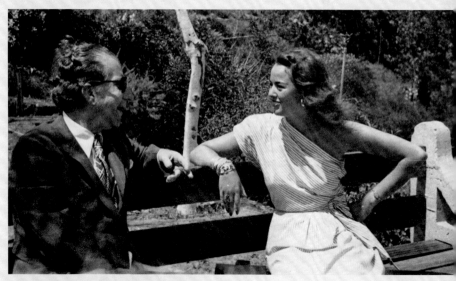

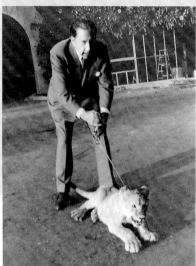

J. Paul Getty with his fifth wife, Louise Dudley Lynch (called "Teddy" after her stage name, "Theodora"), at Inspiration Point, a bluff overlooking the Pacific Ocean, near the future site of the Getty Villa, early 1950s.

Getty with his lioness cub, Teresa, part of the small menagerie of animals he once kept at the Ranch House near Malibu, 1950s.

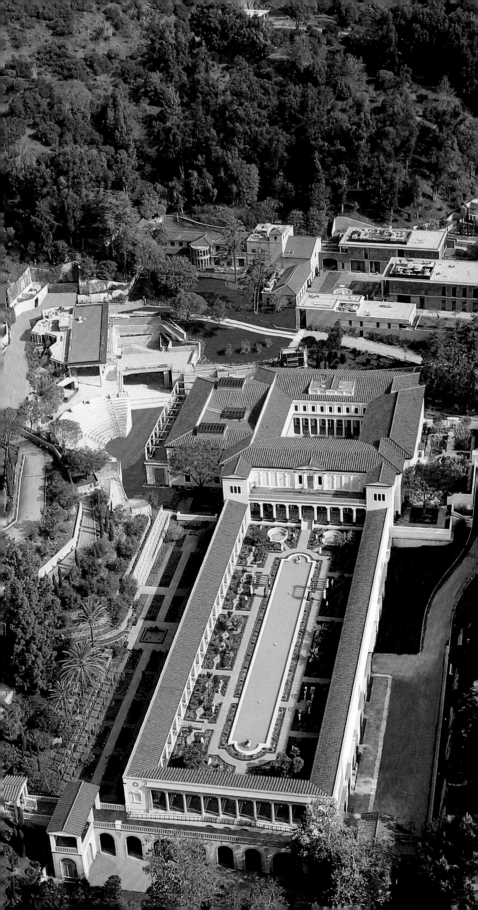

2 The Getty Villa

IN 1934 J. PAUL GETTY BUILT A HOME next to one constructed by the newspaper magnate William Randolph Hearst on the beach in Santa Monica. Later, when Getty visited San Simeon, Hearst's ornate hilltop castle overlooking the Pacific Ocean halfway between Los Angeles and San Francisco, he was impressed by his host's baronial lifestyle and ability to buy an incredible variety of things without seeming to give a thought to the cost. While Getty was much more frugal, the seeds for the Getty Ranch near Malibu and for Sutton Place, his estate in England, were nevertheless planted.

THE RANCH HOUSE After Getty's 1945 purchase of the Ranch House and its surrounding acreage, he filled the two-story structure with his expanding collection of Greek and Roman antiquities and European paintings and furniture, which he had been steadily collecting since around 1930. He also created a small zoo on the property, and for a time, bears, lions, wolves, bison, and gazelles were in residence there.

For about twenty years, after the J. Paul Getty Museum opened to the public in 1954, Getty's modest but important collection was exhibited in the rooms of the Ranch House. Hours were three to five on Wednesday and Saturday afternoons, by appointment only. The Museum was not terribly busy in those early days, with three dozen visitors constituting a good crowd on any given afternoon. But those who came could see French furniture and decorative arts, paintings by Thomas Gainsborough, Titian, and Peter Paul Rubens, as well as the second-century-A.D. Lansdowne Herakles — the most famous piece in the collection at the time and one of Getty's favorite works. The sculpture had been unearthed from the ruins of the Roman emperor Hadrian's villa near Tivoli in 1790 and symbolized, grandiosely, for Getty the continuation of the tradition of the great collectors and philanthropists of the past.

By the late 1960s, as Getty's wealth continued to grow, he and his advisers realized that the collection could no longer be accommodated in what originally had been a residence, despite the specially built gallery added to the house in 1957. Although many designs were presented to Getty (and he was strongly opposed to any modernist proposals), he announced in 1968 his decision to a rather surprised circle of guests at Sutton Place: the new Getty

Since it opened in 1974, the Getty Villa has been a popular destination in Los Angeles, regarded with affection by residents and amazement by visitors from around the world. After the move to the Getty Center in 1997, the Villa was closed for extensive renovations until 2006. It is now exclusively focused on the presentation and study of ancient Greek, Roman, and Etruscan art.

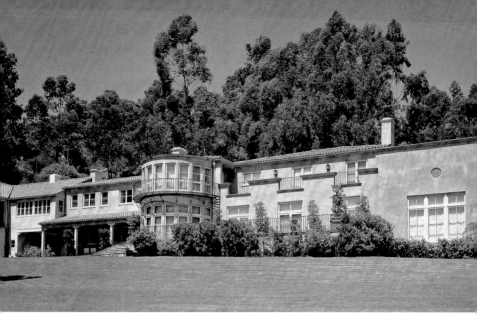

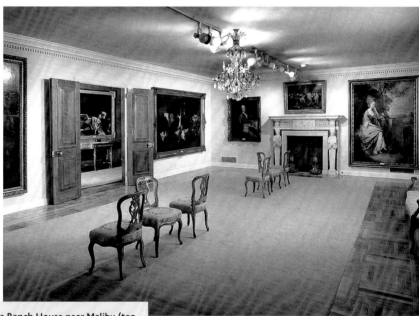

The Ranch House near Malibu (top, as seen in the late 1950s) housed the first galleries Getty installed and opened to the public. The displays included paintings, decorative arts, and antiquities. A long salon in the Ranch House featured paintings (middle). In 1957 a new gallery for antiquities (bottom) was built as an addition to the Ranch House.

Museum would be a re-creation of the ancient Villa dei Papiri in Herculaneum, which had been buried by the eruption of Mount Vesuvius in A.D. 79 and discovered in 1709. The Villa dei Papiri had been the grand home of Lucius Calpurnius Piso, a wealthy Roman collector of literature, hence the "papiri" (papyrus scrolls) found there. Getty, who had traveled extensively in Greece and to Rome and who owned two villas in Italy at this time, had long been attracted to Herculaneum and Piso's villa (in 1955 Getty had even published a novella, *A Journey from Corinth*, about a landscape architect who works for Piso at the villa in Herculaneum).

Getty was also in a sense following an old American tradition of great collectors housing their art in period fantasies: the Venetian palazzo of the Isabella Stewart Gardner Museum in Boston, for example, or the French *hôtel particulier* of the Frick Collection in New York, or the Spanish confection of Hearst's San Simeon. For this project, Getty selected the architectural historian Norman Neuerburg, who, basing his ideas on the original 1754 ground plans of Piso's villa, extrapolated the basic structure for the Getty Villa.

A NEW MUSEUM Ground was broken in December 1970, and construction proceeded rapidly, with Getty making both major and minor decisions from his estate in England. He monitored the process by means of constant reports, large-scale photo boards, and even films, while work on-site was overseen by the Los Angeles architectural firm Langdon & Wilson. The layout of the Museum followed that of Piso's buried house: a large, two-story main block with an atrium, an adjacent inner peristyle with a garden and a triclinium, and a vast 348-foot-long outer peristyle with colonnades, frescoed loggias, garden, and reflecting pool. Inside the Museum, antiquities were exhibited largely on the first floor in a series of small, discrete galleries and around the Inner Peristyle garden, which was modeled

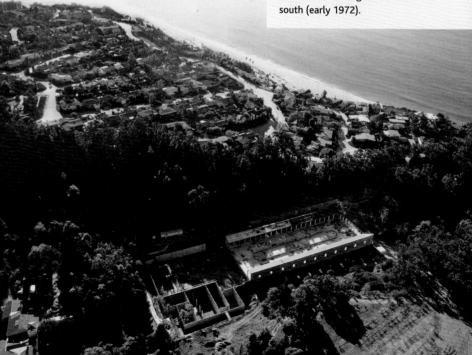

This aerial photo captures the Museum under construction, with its axis perpendicular to the Pacific Ocean, and the residential neighborhoods to the south (early 1972).

BUILDING THE GETTY VILLA

After J. Paul Getty announced his intention to build at the Getty Ranch a reconstruction of the Villa dei Papiri as an art museum, the next question became "How?" Excavation of the Villa dei Papiri in the 1750s, led by the Swiss engineer Karl Weber revealed the residence proper, built around a central hall, and a long rectangular peristyle. Weber's detailed plans of the structure provided the basis for the Getty Villa.

To oversee the ambitious project, Getty hired an English architect, Stephen Garrett, and the architectural firm Langdon & Wilson, which converted Weber's plans into blueprints for the museum. Dinwiddie Construction was contracted to build Getty's villa. On December 21, 1970, several hundred yards from the original Ranch House museum, ground was broken for the new J. Paul Getty Museum.

Construction of the Outer Peristyle and underground parking garage began first, and by the spring of 1971, the

The south side of the excavated section of the Villa dei Papiri just outside of Herculaneum (uncovered between 1986 and 1993).

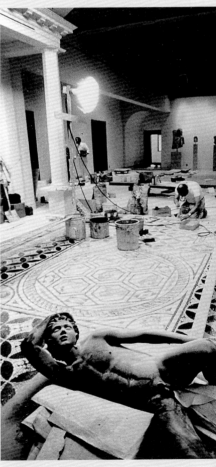

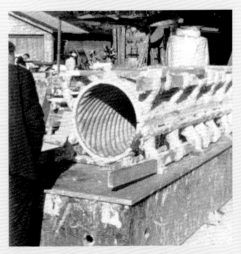

The spiral columns of the West Porch at the Getty Villa were cast in molds such as this one.

Workers toiled night and day, sometimes with sculptures watching, to finalize the galleries.

structural elements for both were in place. As Weber's plan did not mention the building materials of the ancient villa, it was decided that a smooth-finish concrete that simulated plaster be used for the museum building and Outer Peristyle. By January 1972, the columns of the Outer Peristyle and the building's architectural molding were cast in concrete, and the foundation work for the museum building and Inner Peristyle were underway. By the following January, the Outer Peristyle and first floor of the museum were complete, the Inner Peristyle was taking shape, and the construction of the second-floor galleries began.

The subsequent months included the installation of intricate marbles in the halls and galleries, including the so-called Temple of Herakles, built to house one of Getty's most prized works of art, the Lansdowne Herakles. The room's elaborate floor is based on the first one discovered at the Villa dei Papiri and is composed of more than four thousand

pieces of three different types of marble specially cut then sent from Italy.

On January 16, 1974, the J. Paul Getty Museum opened its doors, a fact that greatly pleased its benefactor, who, although he never saw the product of his vision, felt that his money—$17 million of it—was spent wisely.

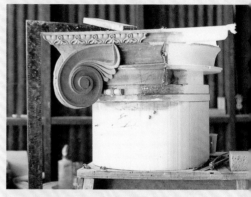

A cast and painted Ionic capital for a column in the Inner Peristyle.

Photo boards, such as the one below documenting the Villa's Outer Peristyle and underground parking garage, were hand-delivered to Getty in England.

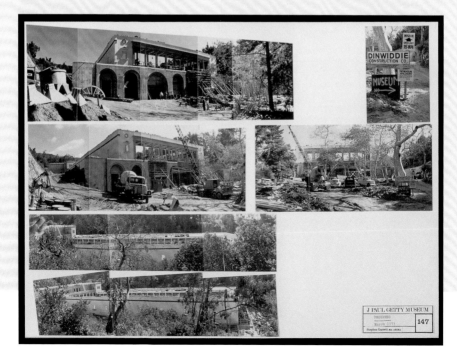

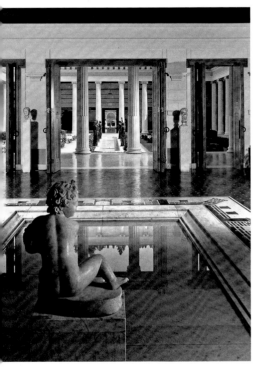

after ancient Roman gardens. Later works of art—primarily late-seventeenth- and eighteenth-century French furniture and old master paintings—occupied the second-floor galleries.

The new J. Paul Getty Museum opened to the public on January 16, 1974. Critics savaged it as historical kitsch; the public adored it. Ultimately, the public's opinion won out, and although Getty never saw the Museum, he was proud of the result, writing in his autobiography, "I felt that the Museum, its Trustees, and I got our money's worth." This statement, from one of the shrewdest businessmen of the twentieth century, was indeed a tribute not only to his own imagination and prodigious wealth but also to all those who conceived, planned, and built the Museum.

Getty's death two years later and his subsequent bequest to the Museum fundamentally changed the scope and reach of the Trust and the Museum. Not only did Getty leave a substantial sum of money, he also placed very few restrictions on how it was to be spent. The Museum was free to purchase works in other media and periods outside of what Getty himself had collected, and it was clear that expanding the holdings and programs would require having a physical home for these works and activities.

Once the decision was made in 1982–83 to select an important site and build on it a center (discussed in the next chapter) for all of the Getty's activities, Trust and Museum officers were faced with another question: what to do with the much-loved Getty Villa and the magnificent property it occupied? While it was no longer large enough to exhibit adequately the expanding collections,

let alone to accommodate the offices and library space required by the newer Trust programs, the Villa clearly was a place people loved to visit and that had always been intended by its founder and its architects as a museum.

A MUSEUM OF ANTIQUITIES As Greek, Roman, and Etruscan antiquities were arguably Getty's first love, and his classical collection—considerably augmented after his bequest—was considered to be one of the finest of its kind in the United States, it seemed clear to everyone that the Villa should reopen as a site in which to exhibit that collection in a setting natural to it, and at the same time to make use of the Ranch House as a place in which to house the antiquities-related activities of the other programs. Preliminary planning began as early as 1987, and while it would be another six years or so before architects were selected and precise designs determined, the increasingly obvious inadequacies of the Villa and its location led curatorial and administrative staff to develop a wish list of improvements.

First, the accessibility of the Museum and the site generally had to be addressed; for example, neither the Auditorium nor the Tea Room could be accessed by the disabled, and the fire roads through the property were too narrow for newer, wider, fire trucks. Second, the entry into the Museum was neither especially cheerful nor true to where an entry would have been placed in an ancient suburban villa. Third, the upper floor of the Museum—in which all the collections except antiquities were displayed—lacked natural illumination, owing to the fact that most of the works of art displayed there were light sensitive, and, as wall space there was at a premium as the collection grew, windows were a luxury. Fourth, the upper floor had to be reconfigured so that visitors could move through the rooms rather than in and out of them, and a clearer way of accessing the upper floor had to be devised, as it was then only reachable by an elevator and stairways that, while clearly marked, were hard to locate.

Beyond these basic improvements to the Museum itself, the Trust administration was eager to add such public amenities as an outdoor theater, a larger and more accessible dining area and bookstore, and facilities specially devoted to visiting schoolchildren and families. Furthermore, it was hoped that the site could be altered so as to provide housing for conservation and research activities, specifically offices for the visiting scholars invited by the Getty Research Institute and laboratories and classrooms for the joint conservation-teaching program that the Getty Conservation Institute was developing with the University of California, Los Angeles.

CHOOSING AN ARCHITECT In 1993, about two years after final zoning permits for the Getty Center were approved and construction of the buildings could actually begin, the Trust administration and the directors of its constituent programs decided upon a competition to choose an architect for the renovation of the Getty Villa. Instead of inviting architects to present plans, a short list of candidates was devised, and those on the list were invited to participate together in a two-day session at the site, during which time

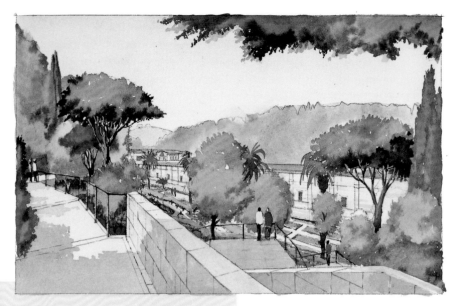

A design rendering by Machado and Silvetti Associates, Inc., from around 1996 showing the hillside gardens with views of the Museum and path leading up to it.

the program directors would describe their activities, and scholars would explain the history of the Getty Villa and of the Villa dei Papiri, its ancient antecedent. Then, each architect or firm would be given an eleven-by-fourteen-inch sketchbook in which, during the following two weeks, to describe in words, drawings, or collage how each would reorganize the site, build the necessary new structures, and reconfigure the interior of the Museum.

On Friday, October 29, 1993, the sessions began. As recounted by the winning architect, Jorge Silvetti, of the American firm Machado and Silvetti Associates, Inc., it was a darkly auspicious beginning for what would prove to be an arduous twelve-year process. As the participants emerged from the darkened Founders Room into the California sun, ash from a major brush-fire nearby fell from the sky, eerily evoking what it must have felt like to have been in Herculaneum as Mount Vesuvius began its devastating eruption almost two thousand years earlier.

THE VILLA REOPENS Although the reopening of the Villa was originally planned for 2001, a long and sometimes contentious process of zoning approval, as well as the challenges of the site and the changing requirements of the Trust, delayed that opening by five years. Finally, on January 28, 2006, the Getty Villa reopened, and the staff, critics, and public have agreed that it was worth the wait. And it would be fair to say that the much-loved—and, indeed, much-maligned—Museum building and the breathtaking Villa environs grew more beautiful, more useful, and truer to their ancient prototype in the hands of Machado and Silvetti, and guided by the Museum's then curator of antiquities and Trust Coordinator of Villa Programs, Marion True. The new suite of twenty-three galleries houses more than twelve hundred objects from the Museum's antiquities collection, filling both floors of the Museum. Six additional galleries offer a year-round schedule of changing and international

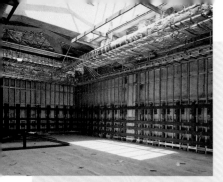

The art-support system (left), hidden behind every gallery wall, allows very heavy objects and cases to be attached simply and safely. The photo below documents the construction of the Villa's compluvium, which, in ancient homes, allowed in rainwater. The Villa's compluvium, however, unlike those in antiquity, can be closed by means of a mechanical shutter.

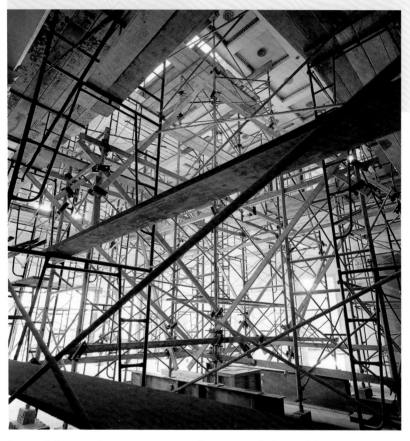

loan exhibitions, bringing treasures from around the world to Los Angeles. The special collections of the Getty Research Institute, rich in materials on the classical world, are also regularly featured.

Today, visitors to the Villa still enter from Pacific Coast Highway but park in an expanded and largely hidden structure instead of underneath the Museum. After leaving the garage, visitors proceed to the Entry Pavilion and then along a path whose rough-hewn and multilayered retaining wall intentionally resembles the gouged-out stratigraphy of an archaeological excavation. Looking down at the extensive landscaping, visitors experience the type of gardens that the Romans themselves would have designed, with the Southern California air and light standing in for those of the Bay of Naples.

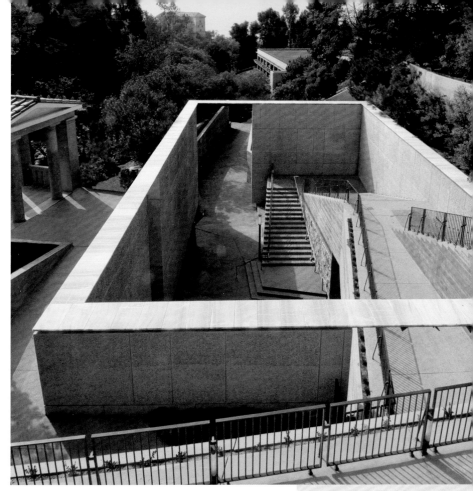

Continuing on, visitors see the Museum's roof and walls. The formal entry begins near the top of the semicircular outdoor Barbara and Lawrence Fleischman Theater—from which practically the whole site and the Pacific Ocean beyond are now clearly visible. On summer evenings, the theater does indeed host performances, but daily it offers itself as a grand descent to the West Porch, the entrance to the Museum. The porch leads into the Atrium, which itself opens onto the Inner Peristyle—exactly as visitors might have entered a dwelling such as the Villa dei Papiri in ancient times.

The Entry Pavilion seen from its upper level, from which visitors can take in views of the Pacific Ocean.

Once inside the Museum, visitors familiar with the old Villa will be struck by how everything seems the same as it was before, only somehow brighter and more finished. The wall paintings, first completed in the mid-1970s by the artist Garth Benton, were restored and then refreshed by Benton himself. The marble floors and wall cladding are largely as they were originally. The first—and only major structural—change is the grand East Stair at the end of the Inner Peristyle and directly in the line of sight from the entrance, thus making clear the entire layout of the building. It leads to the second floor, which is bathed in the natural light flowing from new skylights and now-opened windows.

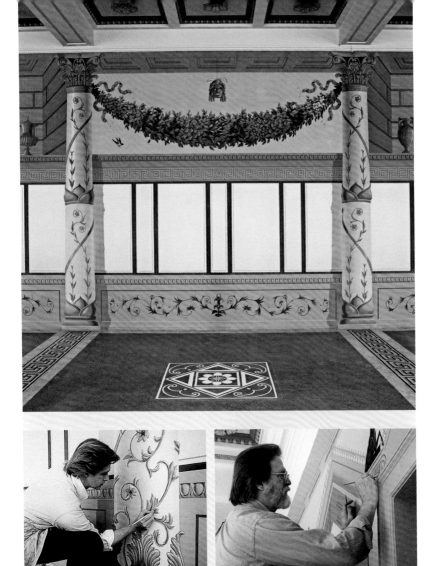

The wall paintings in the Outer Peristyle (above) were modeled after those found in antiquity and were originally painted by the artist Garth Benton (at left, around 1973). For the new Villa, Benton (at right, in 2005) retouched some of the existing frescoes and created an original design for a newly renovated wall.

Just as the building was designed to resemble how a great collector might have lived at the time of the Roman Empire, so the works of art are arranged to give one a sense of their place in the daily and ceremonial life of the ancients. Drawing from these objects, visitors can learn much about the Greeks, Romans, and Etruscans—what they thought, dreamt, and went to war about and how they led their daily lives. While there are several small galleries on the first floor devoted to specific types of objects—silver, glass, bronze, and terracotta, for example—the major pieces of the collection are presented neither chronologically nor by medium. Instead, they are displayed

A CLOSER LOOK AT THE VILLA GALLERIES

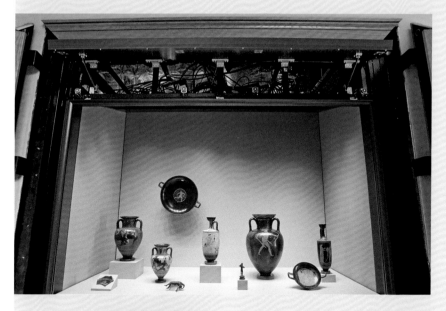

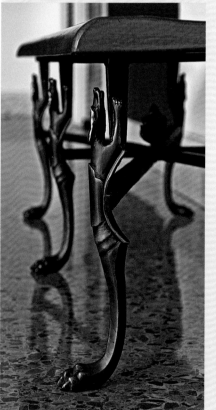

The display cases at the Villa (above) were made by the German company Glasbau Hahn and are equipped with humidity and climate controls, specialty lighting systems, seismic protectors, and security sensors. This modern chair (left) contains legs inspired by ancient Roman works of art. In the photo below, sculptures in the Inner Peristyle may resemble ghosts but were merely covered to protect them during construction.

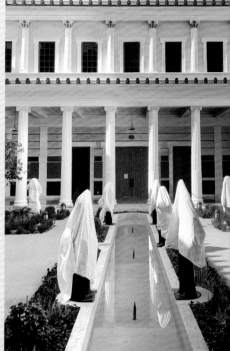

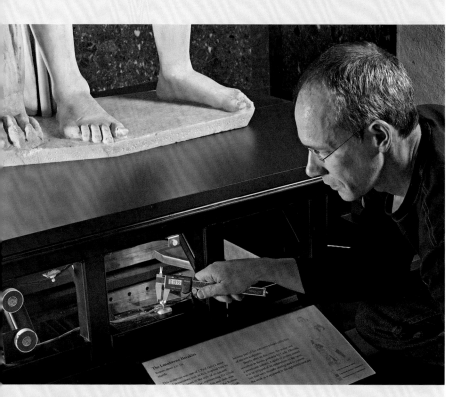

SEISMIC PROTECTION

Nature has the power to unleash great force—a fact that the ancients knew all too well. Despite its tranquil setting, the Getty Villa sits on ground at risk for some of the most destructive earthquakes in the world. Long-term preservation is one of the primary efforts of the Antiquities Conservation Department and encompasses collections care and disaster mitigation. Museum conservators and mount makers for antiquities have worked for over two decades to develop a variety of methods aimed at reducing the risk of earthquake damage to the collection. These include installing sculptures on bases fitted with specially designed seismic isolators (above) and securing works to the floor with anchors or plugs, shown in the photo below during construction before the gallery floor was finished.

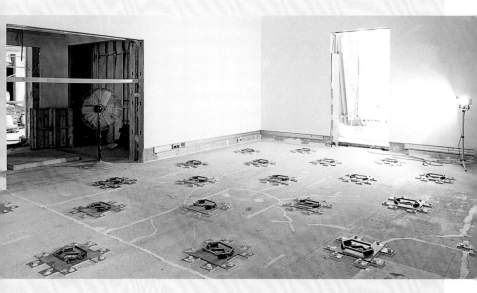

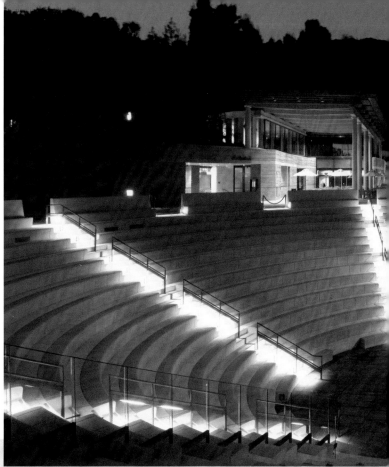

Night at the Villa (above) with a view of (clockwise from left) the Fleischman Theater, Cafe, Auditorium entrance, and Museum. The East Stair (left), clad in yellow marble from Spain, provides easy access between the two floors of the Museum.

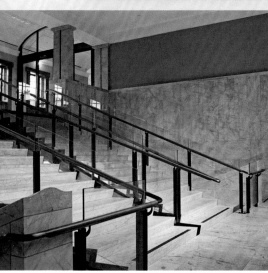

in spacious galleries organized by theme, including: Dionysos and the Theater, Gods and Goddesses, Mythological Heroes, Stories of the Trojan War, Monsters and Minor Deities, Animals in Antiquity, Athletes and Competition, Women and Children in Antiquity, and Arts of Greco-Roman Egypt (with a real mummy!).

There are also numerous public events at the Villa. The new Auditorium hosts an ambitious performance and lecture program. Opposite the Auditorium is a spacious Museum Store and Cafe with indoor and outdoor seating.

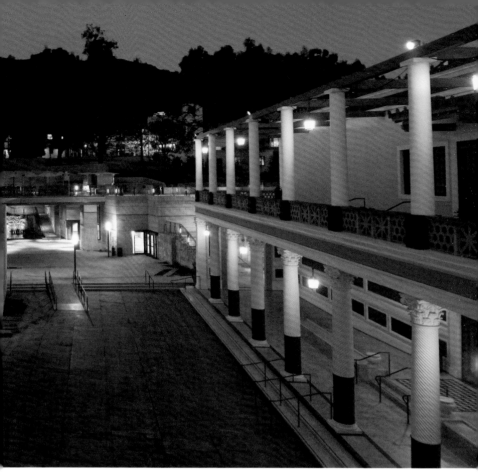

From here and across a broad lawn, visitors can see the old Ranch House, but it, as well as the new structures for conservation and administrative offices nearby, is closed to the public. These are the spaces in which the work of curators, visiting scholars, staff, and student-conservators takes place.

GETTY'S LEGACY J. Paul Getty's connection to the lives of the ancients, his love of the arts of antiquity, his great philanthropy, and his intellectual curiosity permeate the Villa even today, more than thirty years after his death. It was his wish that "every visitor at Malibu feel as if I had invited him to come and look about and feel at home.... I hope it will prove to be as beautiful as I imagined it and that everyone who wants will have a chance to see it." Getty also stipulated that admission to the Museum be free of charge. Although Getty died without ever personally experiencing the Villa, there is something oddly comforting and poetic about the fact that he is buried at the site, on a bluff overlooking the Pacific Ocean. About the original institution that opened in 1974, Getty wrote: "Museums do not just happen. Nor are they the work of any one person. Numerous dedicated people contributed thought, time, energy, and work—and above all expertise and talent—to the building and success of the Getty Museum."

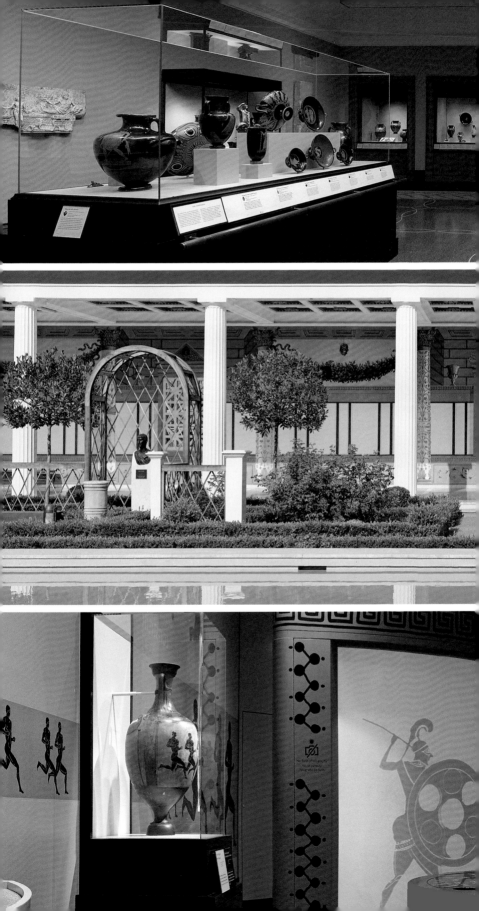

Vases are made of clay
and baked in a kiln
Las vasijas están hechas de barro
y son cocidas en un horno

Vases are shaped by hand
Las vasijas son formadas a mano

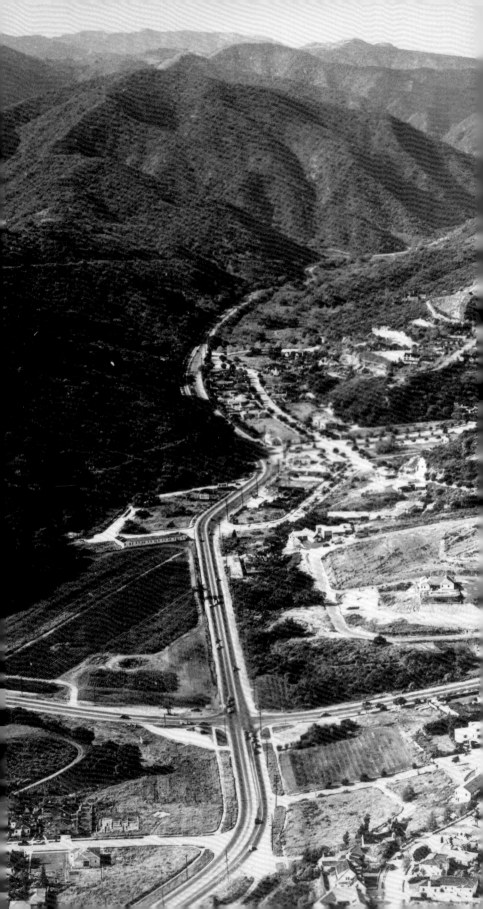

3 Building the Getty Center

THE DECISION TO BUILD THE GETTY Center was a defining moment in the history of the J. Paul Getty Trust. The reasons for that decision were both practical and philosophical.

During their first few years, the new Getty programs found temporary housing in rented space around Los Angeles. The Trust's administrative offices were in Century City, the Center for the History of Art and the Humanities occupied several floors of an office building in Santa Monica, and the Conservation Institute worked out of facilities in an office park in Marina del Rey. It was clear from the start, however, that the programs would require specialized facilities in order for their activities to move ahead. It was equally evident that, in order for them to interact in ways that would generate creative new thinking and innovative approaches to their fields, they should be housed together. Moreover, as the Getty Museum expanded its collections to include four new curatorial departments—Drawings, Manuscripts, Photographs, and Sculpture—it became apparent that the existing Getty Villa would not offer adequate space to display the collections and could not be easily enlarged.

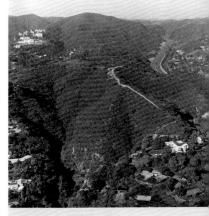

Hilltop purchase, roughly 750 acres, 1983.

SELECTING THE LOCATION Beyond simply finding a location to house the Getty's growing departments and programs, Trust President and Chief Executive Officer Harold Williams and the trustees recognized that they had a rare opportunity to provide a unique cultural resource for the city of Los Angeles. They understood that whatever they finally decided to build should place memorable architecture on a remarkable site. Just as important, in a city as large and sprawling as Los Angeles—and in deliberate contrast to the Villa—the facility needed to be someplace central and accessible.

Several possibilities were considered, including a large tract at the Veterans Administration Medical Center in Westwood and on the grounds of the Ambassador Hotel near downtown. But when a plot of land in the foothills of the Santa Monica Mountains became available, it was the instant front-runner.

A north-facing view from 1944 of the pass through the Santa Monica Mountains, the future home of the San Diego Freeway and the Getty Center.

The opportunity to build on such a large hilltop property—the site, together with an adjacent parcel was 742 acres in all—was unusual to say the least; it seemed unlikely that a similar tract would be offered again in Los Angeles. The Trust bought the land in September 1983.

SELECTING AN ARCHITECT In the fall of 1983, the Getty empaneled an advisory group, chaired by Bill Lacy, then president of New York's Cooper Union for the Advancement of Science and Art, to guide the Trust in selecting an architect. Rather than hold a design competition, the standard practice for cultural institutions and other major architectural projects, the committee instead recommended a unique process that included interviews with architects and their clients as well as visits to the designers' most important previous buildings. The trustees agreed. The committee compiled a list of thirty-three candidates whose firms ranged in size and location and who had produced consistent and distinguished bodies of work.

The invitation to the architects included a site map and explained the Trust's major requirements: "The buildings must be technically sound in construction. They must serve and enhance the programmatic purposes of the institutions and their relationship to each other. They must be appropriate to the site and responsive to its uniqueness. They must achieve the above three qualities in a manner that brings aesthetic pleasure to the building's occupants, visitors, and neighboring community."

In the fall of 1983 the committee sent the invitation to the elected architects, asking the recipients to submit background materials and slides of their firms' completed projects, a list of clients, and, most important, a short essay describing how they, if chosen, might approach the commission. Seven semifinalists were then invited to visit the site and discuss their ideas with the committee. In turn, the committee toured at least two buildings by each architect and, with the architect as guide, visited the firms' offices and spoke to past clients.

After several months, three finalists were selected: Fumihiko Maki, of Japan; James Stirling, of Great Britain; and Richard Meier, of the United States. In October 1984—thirteen months after acquiring the property—the Getty named Richard Meier & Partners as architect. Meier had recently

HIGH MUSEUM, ATLANTA
Before selecting the final architect, the committee visited projects completed by the three finalists. They also talked to previous clients. Here the committee takes in the High Museum, designed by Richard Meier.

been named the winner of the 1984 Pritzker Prize, widely regarded as the highest professional honor in architecture, and he had garnered international accolades for his design of cultural institutions, such as the High Museum in Atlanta and the Decorative Arts Museum in Frankfurt.

VISITING OTHER MUSEUM SITES Over the course of several months, Meier and his associates, accompanied by the Getty's leadership, journeyed to museums and research institutions throughout the United States and Europe. Their itinerary ranged from the Frick Collection in New York and the Freer Gallery in Washington, D.C. to the Alte Pinakothek in Munich, Germany; the National Gallery in Edinburgh, Scotland; the Herzog August Bibliothek in Wolfenbüttel, Germany; and the Certosa del Galuzzo, a monastery in Florence, Italy.

Of their shared research mission, John Walsh, then director of the J. Paul Getty Museum, said: "The objective was not to find features to copy, but to study sites that have particular suggestive power for us, to see buildings that we think especially successful in one way or another. Away from our daily routines, stirred by common experiences, we were able to push ideas for our own project further. It was valuable just to compare our reactions with the architect's and vice versa and in the process begin to know one another's minds and vocabularies."

Among the many highlights of the trip was the visit to the Herzog August Bibliothek, a research center and library that was a close parallel in terms of function to the Getty Center for the History of Art and the Humanities (later the Getty Research Institute).

The gardens and hill towns of Italy also inspired elements that would all prove essential in the design of the Getty Center: the scale and textures of outdoor spaces, the sensory impact of moving water, the relationship between intimate alcoves and open plazas, and the entire dialogue between buildings and their surrounding garden spaces.

EUROPEAN VISITS

Once Meier was selected in October 1984, the committee and architect toured other museums internationally over the following months. The goal of these trips was to experience the character and spirit of the places. Among the sites visited were the Alte Pinakothek (left) in Munich and Hadrian's Villa (above) in Tivoli, about nineteen miles outside of Rome.

UNIQUE CHALLENGES OF THE GETTY SITE The hilltop location was both an inspiring and controlling factor. When Meier first described his concept for the site plan in 1986, he was clear that he saw the land and the buildings as an integral part of the urban fabric of Los Angeles. "The spectacular site," he wrote, "invites the architect to search out a precise and exquisitely reciprocal relationship between built architecture and natural topography." His vision was that of "a classic structure, elegant and timeless, emerging, serene and ideal, from the rough hillside, a kind of Aristotelean structure within the landscape. . . . The two are entwined in a dialogue, a perpetual embrace in which building and site are one."

Developing the site, however, which had been zoned for residences, depended on securing the approval of local residents as well as of the Los Angeles Planning Commission. The Getty worked closely with elected officials and homeowner representatives to establish a basic framework for the design and operation of the Center. A Conditional Use Permit created a set of 107 written conditions, and the master plan was approved in 1987.

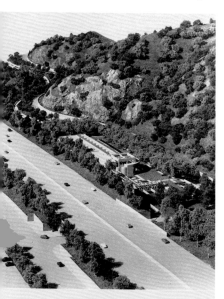

Preliminary work such as this maquette examined the impact the Getty Center would have on the surrounding landscape.

It required six months for the Getty's staff to evaluate all their buildings' requirements and integrate them into a comprehensive written program. The document handed over to Meier in early 1986 stressed the objective of locating Getty programs together so that each could be strengthened by the others. It called for structures that responded "functionally and aesthetically to the distinctive nature of each program" and emphasized the need for buildings with a human scale that would lend themselves to the humanistic pursuits at the heart of the Getty's mission.

MANY MODELS ARE PREPARED Meier's office created many meticulous three-dimensional models and preparatory drawings from the time Meier was selected as architect for the Center in 1984. These included the site master plan, approved by the Los Angeles Planning Commission in 1987; the schematic design of the Center, approved by the Getty the following year; and the final design of the Center, approved in the spring of 1991. During this period there were also in-depth discussions with Getty personnel to ensure that all the buildings would fulfill the needs of their occupants.

Despite the many changes to the plan in the course of the architect-client dialogue, Meier's original vision for the Center stayed true. After the comple-

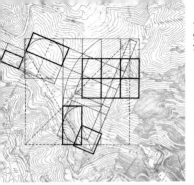

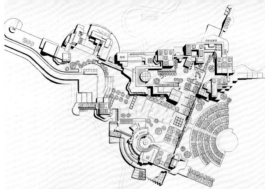

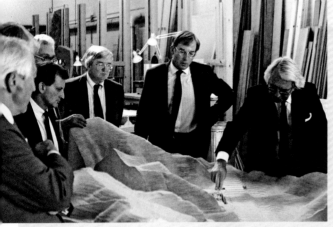

Meier responded to the natural topography of the site, situating the buildings along the ridges that form a Y-shaped axis. The site plan at top left shows how geometric relationships were developed along the two ridges to establish placement of building masses. At top right is an overall site plan. Both plans were made in September 1988.

Meier, at far right in the photo above, articulating his designs to Trust and program leaders. Architectural and site models were crucial for developing the arrangement and flow of the buildings and establishing the nature of the experience for viewing art in the galleries. The model at right shows an early concept for the louvers that control natural light in the upper-level galleries. The model below depicts (clockwise from top left) the Museum, Research Institute, Restaurant/Cafe, Arrival Plaza, and East Building.

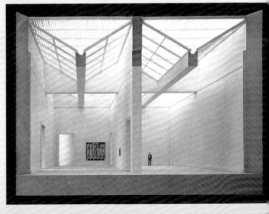

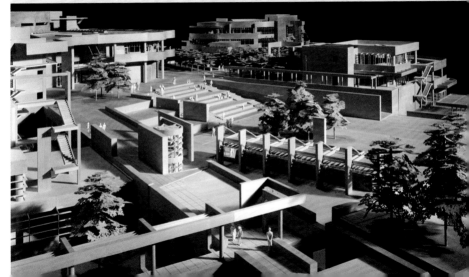

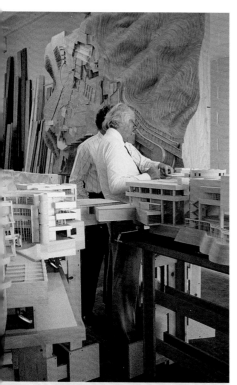

Surrounded by topographical and architectural models, Meier and an associate discuss details of the Getty Center plan.

tion of the building of the Center, he wrote: "When I compare early sketches and design models with what has been built, it is remarkable how the original conceptual ideas remained intact—particularly since every piece of the complex was discussed, scrutinized, redesigned, reworked, and repriced."

FEATURES OF THE FINAL PLAN

The layout of the buildings, gardens, and open spaces follows the site's physical topography. A twenty-four-acre plot in the southernmost part of the site had been chosen for the buildings and campus even before Meier was selected as architect. This plot was divided naturally by a canyon into a Y, with two ridges diverging to the south. Meier's plan positioned the Museum on the eastern ridge—thereby visible to its potential audience—and the Research Institute on the more secluded western ridge, facing the ocean. A grand garden was to go in between the ridges in the former canyon. Where the ridges met, Meier located the main public service areas: the Tram Arrival Plaza, Auditorium, and Restaurant/Cafe; adjacent to those, on the northeast side, would be two buildings to house offices for the Trust, Conservation Institute, Grant Program, and Education Institute.

At the outset of the design process, the Museum was the most established part of the Getty. Its collections are not as encyclopedic as those of the Los Angeles County Museum of Art but are concentrated in several key areas; their aim is depth rather than breadth. The idea of housing those collections in a series of discrete but connected buildings set around gardens and terraces took shape in early discussions between the architect and the Museum's staff. Such a design contributes to a sense of intimacy as well as improved circulation; visitors are encouraged to stop, rest, and enjoy a change of perspective.

The Research Institute presented the most striking instance of the design process, influencing not only the building's form but also its content. In many ways the Institute, still in its formative years, was defining itself at the same time its home was being designed and built. Meier's first schematic presented a variation on a traditional form, with clearly appointed areas for books, archives, visiting scholars, and staff functions. A central reading room would serve as the primary spot for intellectual and social interaction.

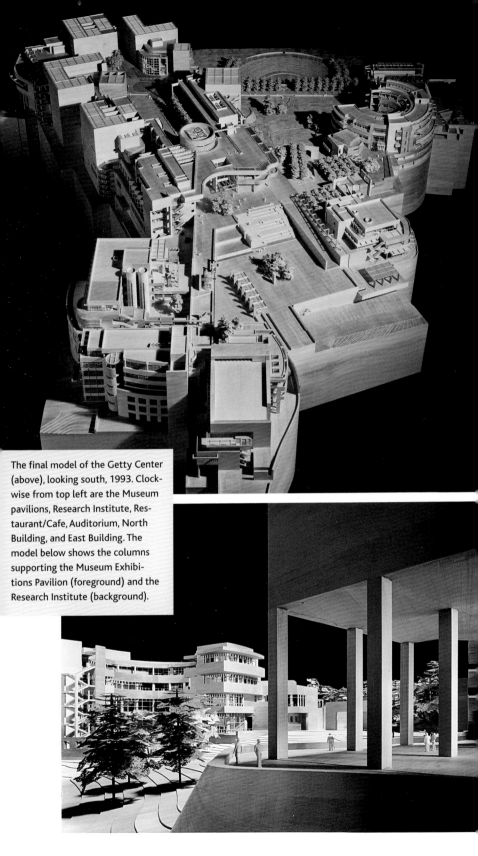

The final model of the Getty Center (above), looking south, 1993. Clockwise from top left are the Museum pavilions, Research Institute, Restaurant/Cafe, Auditorium, North Building, and East Building. The model below shows the columns supporting the Museum Exhibitions Pavilion (foreground) and the Research Institute (background).

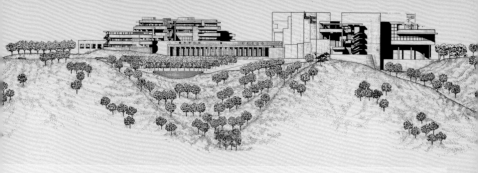

Due to the height restrictions of forty-five feet on the west side of the site and sixty-five feet on the east imposed by the Conditional Use Permit, more than half the space of the Getty Center was placed underground. Most of the buildings are three stories above ground and three below.

The plan responded to the original conception of the Research Institute but lacked its desire for fluidity, adaptability, and means for integrating the scholars, staff, and collections. The final result, arrived at after numerous productive collaborative sessions between Meier and Institute leaders, was a circular building with dynamic, flexible spaces that allowed for both privacy and transparency.

Meier described the L-shaped East Building that houses the Conservation Institute and the Foundation as "the most 'Californian' building in the complex." Many of the corridors—even the elevators—are on the exterior. Covered passageways connect offices to the Conservation Institute's Information Center and the building as a whole to the public walkway. He sought to capture the "qualities of light and openness" that characterize the Southern California buildings by Richard Neutra, Rudolf Schindler, and Frank Lloyd Wright, as well as the historic Case Study houses of the 1950s and 1960s.

MATERIAL SELECTION The travertine cladding on the site's retaining walls and the bases of buildings recalls the materials used on great structures since antiquity. At the same time, it grounds the Center in the hillside, emphasizing the relationship between the natural and the built. Porcelain-enameled metal panels and glass curtain walls stretch around the buildings' upper stories. These materials are more pliable than stone, making them an ideal fit for many of the structures' fluid, sculptural forms. The beige tone of the panels complements the stone, while their smooth surface provides a contrast to the stone's rough texture. White metal panels cover walls not visible from off-site.

CONSTRUCTION BEGINS Building a large complex on the hilltop site presented numerous logistic and engineering challenges. There were no paved roads, utilities, or water source. Dinwiddie Construction Company, which had been selected in February 1987 to be the general contractor for the Center (and had built the Getty Villa in the early 1970s), began preparing the site for construction. The first steps were to establish a staging area at the bottom of the site and to build both a million-gallon water reservoir and a parking structure for the construction workers and project staff. In 1989 construction of the lower parking structure was launched, followed by the grading for the main

Mock-ups of proposed materials (above and right) were reviewed for surface quality and texture. Travertine is the most memorable material used on the site, but glass and metal are also employed and were carefully considered as important contrasts to the rough stone.

buildings in 1990 and the foundation work on the North Building, East Building, Auditorium, Restaurant/Cafe, and Museum in 1992. The next year, workers began installing the structural steel for the East and North Buildings and Auditorium, and the first piece of travertine was set in the East Building.

On January 17, 1994, however, a 6.7-magnitude earthquake struck the San Fernando Valley community of Northridge, thirteen miles to the north of the Center project. Years earlier, geologists completing a study of the future Center site had identified an ancient, inactive fault but ultimately concluded that the terrain was stable and could withstand the shaking of a large temblor. Their predictions were proven right by the Northridge quake, which brought a relatively small amount of damage to the foundations and frames of the buildings under construction. However, cracks in the steel frame of the North Building were detected, causing the Getty to halt construction and to confer with its structural engineers, Robert Englekirk Consulting Structural Engineers, Inc., about how best to proceed. After conducting a series of tests—which resulted in the landmark formation of new, higher standards in the construction of steel-frame buildings—from May to August of 1994 the building team retrofitted the erected steel joints that were shown to be vulnerable by the Northridge earthquake.

Later in the year, the foundation work for the Research Institute was initiated, the installation of the structural steel for the Museum commenced, and the lower parking structure and tram station were completed.

TRAVERTINE

Although Richard Meier is famous for the white metal panels he has often used as the outer skin of his formally elegant buildings, he knew early on that he wanted to clad the Getty Center in stone. Because of the way it grounds built structures in the earth, stone brings a sense of permanence. For this reason, stone has been used throughout history as the primary material for public buildings.

Meier, however, rejected the smooth granite that is so often used for buildings today. He wanted what he described as "a stone that looks like stone, that feels like stone." Finding it—especially the 1.2 million square feet needed to cover the Getty Center—required a worldwide search. Meier eventually settled on travertine from Bagni di Tivoli, near Rome.

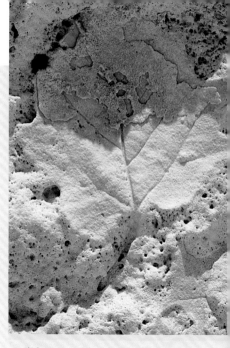

Cleft cutting the travertine revealed fossils and iron-stained cavities that show the stone was formed in a bubbling, mineral-rich lake. Detailed impressions of leaves, feathers, fish, and shells can be seen in the Center's walls and floors.

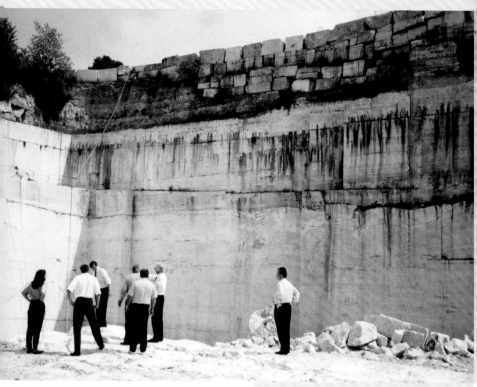

The quarries that supplied the Getty Center were those used by the Romans to build the Colosseum.

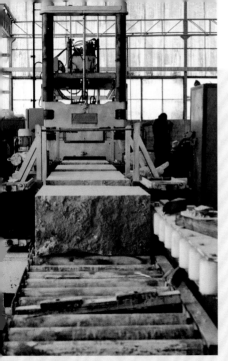
Special machinery at the Mariotti factory cuts the stone, February 1993.

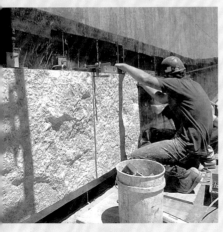
Meier designed a special mortar-free mounting technique for use on the Center's facade. Each block is fitted with stainless steel wall anchors that hook the stone into place. A special backing wall protects the buildings from rain, which runs through the open joints between each stone. This shields the surface of the travertine from streaking and wear. The separation also prevents the blocks from touching in the event of an earthquake.

Travertine, a type of limestone, weighs less than granite or marble and is more plentiful. At the family-owned Mariotti quarries, Meier's team worked closely with Carlo Mariotti and his sons for more than a year to develop a technique that would yield the rough texture the architect envisioned. The method they settled on used a guillotine to split blocks of travertine along their natural fissures.

In all, nearly 16,000 tons of travertine were transported by barge from Italy in 100 trips—via the Atlantic Ocean and the Panama Canal—to build the Getty Center. Most of the more than 295,000 blocks are 30-inch squares and between 1.6 and 5.3 inches thick; each weighs about 250 pounds. Several large pieces of travertine, including benchlike slabs quarried in the nineteenth century and weathered for over a hundred years, struck Meier as especially beautiful.

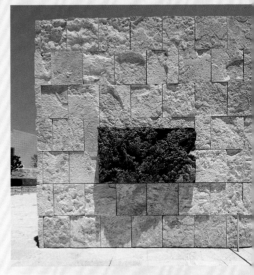
Meier selected some stones based on their texture, color, and fossils to be displayed in public areas throughout the site. About a dozen are incorporated into the regular grid "to break things up and mark a key point," according to Meier.

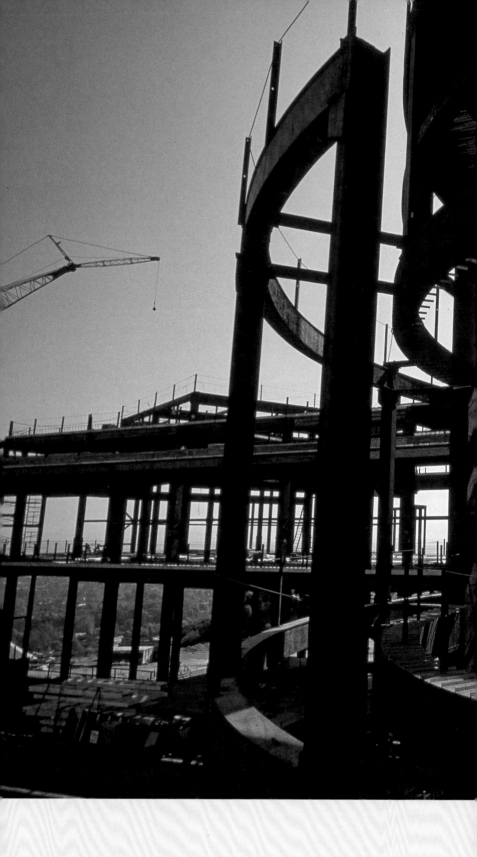

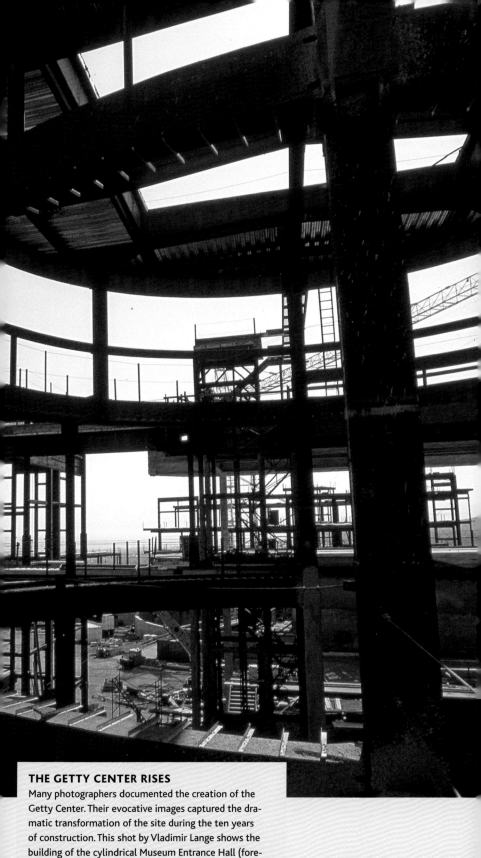

THE GETTY CENTER RISES
Many photographers documented the creation of the
Getty Center. Their evocative images captured the dra-
matic transformation of the site during the ten years
of construction. This shot by Vladimir Lange shows the
building of the cylindrical Museum Entrance Hall (fore-
ground) and the Exhibitions Pavilion (left).

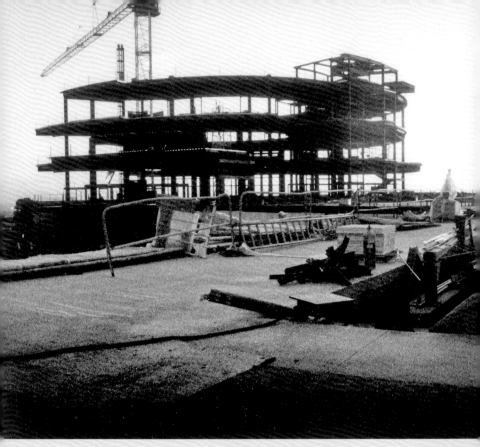

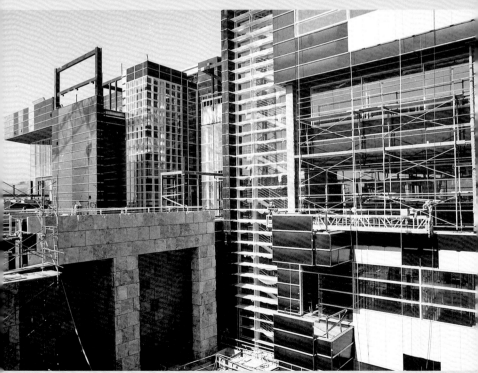

Photos by Dennis Keeley (top), Howard Smith (bottom left), and Joe Deal (bottom right) record, respectively, the construction of the Research Institute and Restaurant/Cafe, Auditorium and North Building, and Museum Entrance Hall.

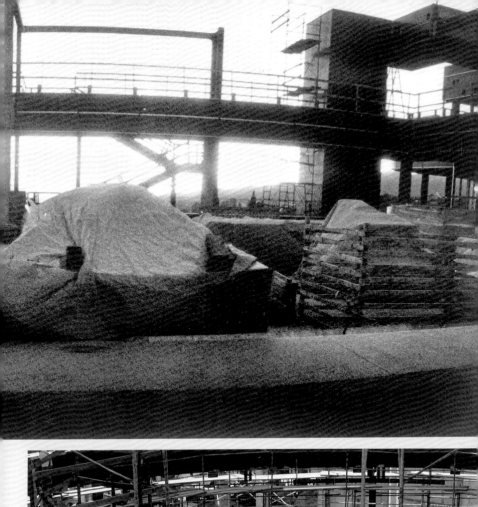
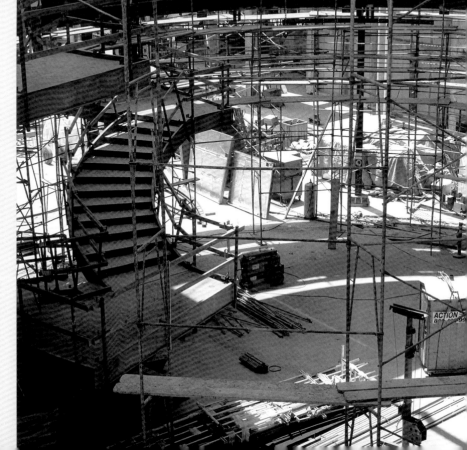

LANDSCAPING THE GETTY CENTER SITE In consultation with Richard Meier, the landscape architecture firm Olin Partnership, with Emmett L. Wemple & Associates, developed plans for landscaping the 110-acre perimeter zone that encircles the central 24-acre campus. (The remainder of the site was left in its natural state.) Some three thousand native oaks, one hundred large Italian stone pines, nearly two thousand other saplings, and acres of shrubs and ground cover were planted—stabilizing and greening the hillside surrounding the Center. Many large trees growing on the property before construction began were boxed and replanted. Extensive conservation and preservation measures help protect the site from fire, soil erosion, and the effects of earthquakes.

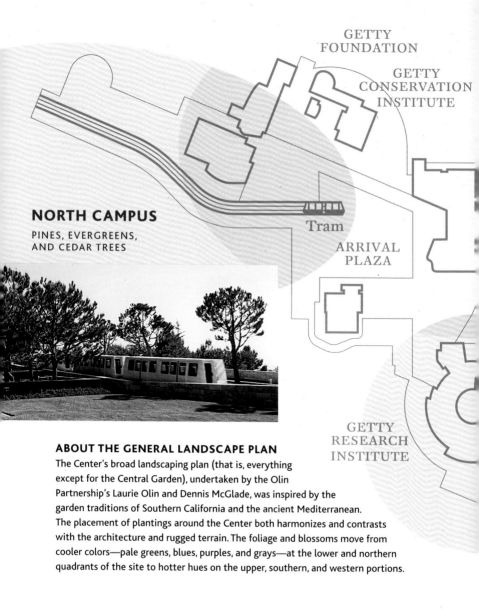

GETTY FOUNDATION

GETTY CONSERVATION INSTITUTE

NORTH CAMPUS

PINES, EVERGREENS, AND CEDAR TREES

Tram

ARRIVAL PLAZA

GETTY RESEARCH INSTITUTE

ABOUT THE GENERAL LANDSCAPE PLAN

The Center's broad landscaping plan (that is, everything except for the Central Garden), undertaken by the Olin Partnership's Laurie Olin and Dennis McGlade, was inspired by the garden traditions of Southern California and the ancient Mediterranean. The placement of plantings around the Center both harmonizes and contrasts with the architecture and rugged terrain. The foliage and blossoms move from cooler colors—pale greens, blues, purples, and grays—at the lower and northern quadrants of the site to hotter hues on the upper, southern, and western portions.

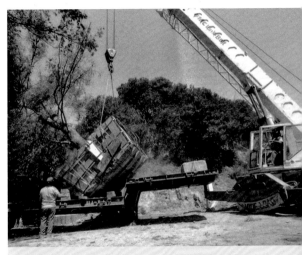

Thousands of trees and native shrubs were planted to minimize the threat of fire and erosion and in response to the need for drought-tolerant materials. To save the site's California live oaks, fifteen mature trees were moved out of the path of construction and transplanted to other locations on the property.

MID-CAMPUS

SWEET GUM, CYPRESS, AND CAMPHOR TREES

J. PAUL GETTY
MUSEUM

SOUTHERN PROMONTORY

CACTUS AND SUCCULENTS, REMINDERS OF LOS ANGELES'S DEPENDENCE ON WATER IMPORTED FROM MILES AWAY

CENTRAL
GARDEN

GETTY RESEARCH INSTITUTE

EDIBLES AND FRUIT-BEARING PLANTS, A METAPHOR FOR THE FRUIT OF KNOWLEDGE

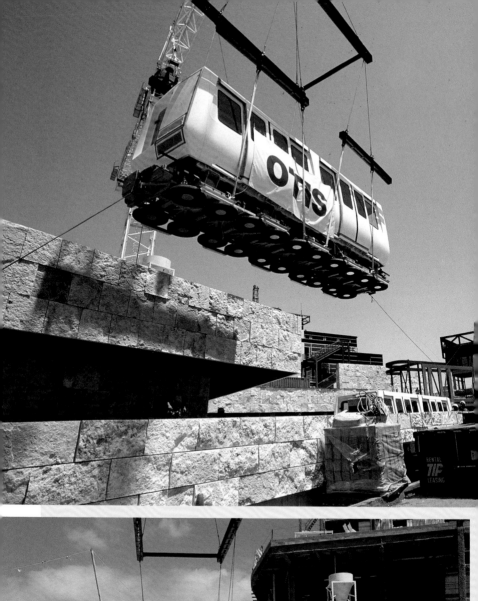

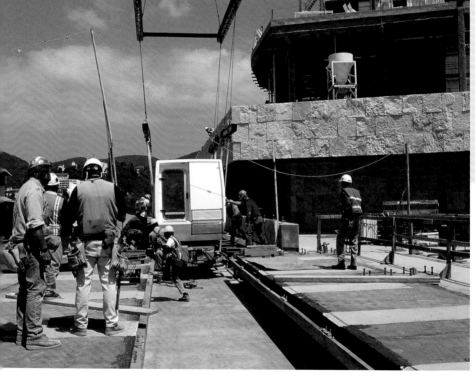

TRAM

Whether they come by car, by bus, or on foot, visitors begin their experience of the Getty Center with a five-minute ride on a driverless, computer-operated electric tram. The ride begins at the Lower Tram Station, which stands over a twelve-hundred-car underground parking structure by the Center's main entrance. As visitors travel along the winding, wooded route to the top of the hill—about three-quarters of a mile—they are treated to constantly changing views of the hillside, city, and Center.

This transportation system was designed for the Center by Otis Transit, a division of the Otis Elevator Company. The tram might best be described as an elevator that runs horizontally instead of vertically. There are actually two separate trams, each with three cars. The quiet, pollution-free vehicles glide on a cushion of air generated by electric blowers. The cars are attached to a cable along a single elevated guideway. As one tram travels uphill, the other runs downhill, bypassing the first at the wider center portion of the guideway. The system was the first of its kind on the West Coast.

The trams arrive for installation in late 1994, above and left. Shown below are the large cables and wheels (located beneath the Museum, near the Central Security office) that work to move the tram cars.

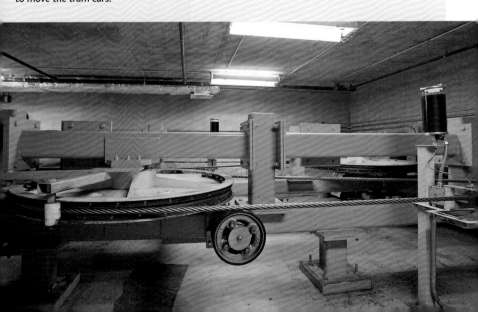

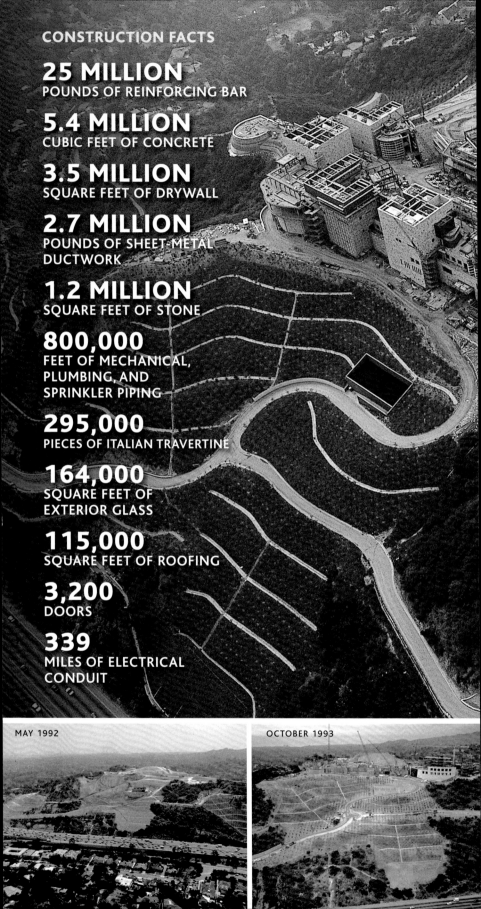

CONSTRUCTION FACTS

25 MILLION
POUNDS OF REINFORCING BAR

5.4 MILLION
CUBIC FEET OF CONCRETE

3.5 MILLION
SQUARE FEET OF DRYWALL

2.7 MILLION
POUNDS OF SHEET-METAL
DUCTWORK

1.2 MILLION
SQUARE FEET OF STONE

800,000
FEET OF MECHANICAL,
PLUMBING, AND
SPRINKLER PIPING

295,000
PIECES OF ITALIAN TRAVERTINE

164,000
SQUARE FEET OF
EXTERIOR GLASS

115,000
SQUARE FEET OF ROOFING

3,200
DOORS

339
MILES OF ELECTRICAL
CONDUIT

MAY 1992

OCTOBER 1993

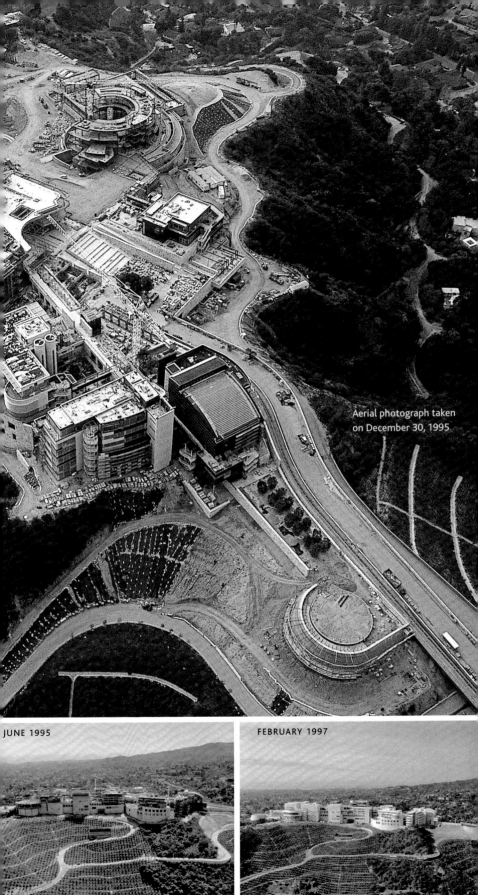

Aerial photograph taken
on December 30, 1995

JUNE 1995

FEBRUARY 1997

Alfred Galvan

Don Guzzi

Joe Deal

Ernest Lerma

Jay K. Choi

WORKERS' PORTRAITS

On any given day, there were six to seven hun-
dred workers on-site (at peak construction,
twelve hundred), pouring concrete, hauling steel,
welding joints, and installing the mechanical and
electrical systems. By project's end, the building
of the Center had created over thirteen thousand
construction-related jobs. These photographs of
construction workers and artisans were taken by
Bruce Bourassa, a Dinwiddie Construction Com-
pany foreman, on the Getty Center site.

Kevin M. O'Brien

Edmundo Lopez

Chris Schienle

Will Anderson

Marty Robinson

Danny Cho

Robert Mendoza

Roxanne Klatt

THE CENTRAL GARDEN In 1992, as Getty administrators reviewed Meier's preliminary concept for the Central Garden, they concluded that they wanted something that was a work of art in its own right, rather than simply a backdrop for the architecture. This presented an opportunity to incorporate an additional aesthetic sensibility into the design of the Center—one that would

contrast with Meier's classic modernism, with its rigorously geometric forms—making the visitor's experience richer and more meaningful overall.

That goal led to the commissioning of a site-contextual piece by the artist Robert Irwin for the Central Garden. Not surprisingly, the tensions—creative or otherwise—between architect and artist were present throughout the planning and building stages. Over the next year, however, Irwin created a plan for the area that sprang from his response to the powerful, controlled geometries of the architecture and the site itself.

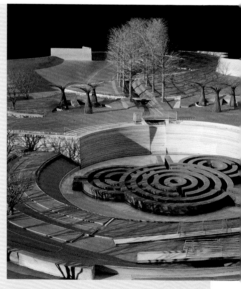

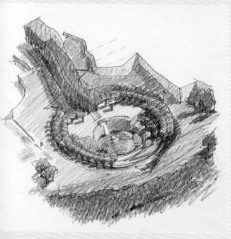

Irwin's plan for the Central Garden was rendered as a series of separate drawings to express the various components of the area (middle and bottom left). An early model (above) shows the azalea maze and overall terrain. Irwin also made a series of photo collages of plants and flowers (top left) that explored different ground-cover configurations and color and texture relationships.

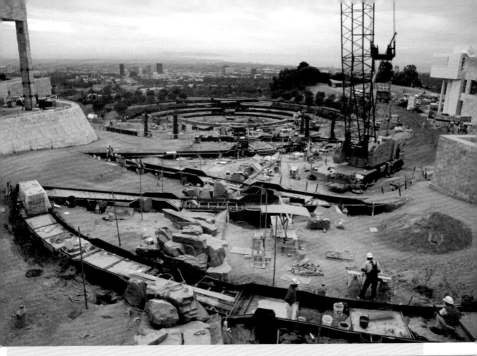

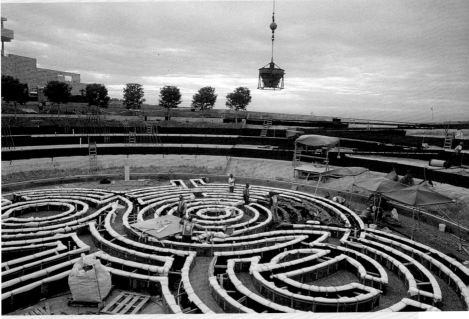

Construction views of the Central Garden walkway (top), floating azalea maze (middle), and streambed that passes under a bridge (bottom).

GALLERY INSTALLATION The staffs of the Museum and Research Institute did not move to the Center until 1997, a year after their colleagues. Much of that time was required for the transportation and installation of the artworks. The J. Paul Getty Museum at the Getty Villa officially closed on July 6, 1997, the upper-level galleries having closed in April of that year in order to transport many of the non-antiquities collections to the Getty Center. Art could not be installed at the Center until the Museum's galleries had been cleared of the destructive chemicals found in new construction materials. In December 1997, with the entire staff in place and the art in the galleries, the Museum was nearly ready to welcome its first visitors.

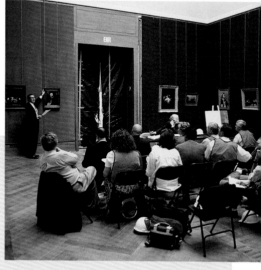

Gallery preparation included the advance planning of the installation aesthetics, such as selecting fabric and wall colors (above). Installation of the art took eight months.

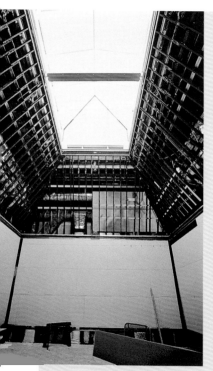

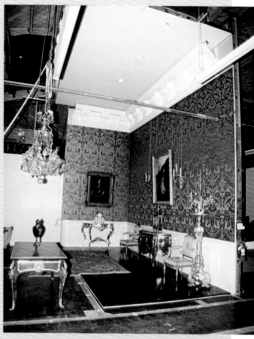

A paintings gallery under construction (above). The design of the Museum's French decorative arts galleries (right) was a critical issue debated early on by Meier and the curatorial staff. Eventually, the architect and interior designer Thierry Despont was brought in to design these specialized spaces.

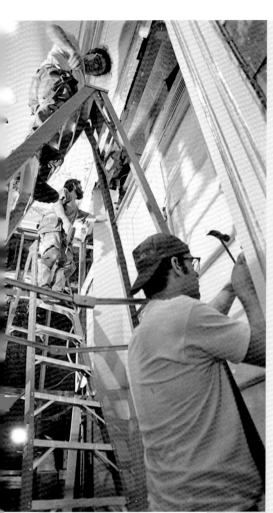

Workers (left and above) installing period paneling in the decorative arts galleries.

Moving the huge James Ensor painting *Christ's Entry into Brussels in 1889* from the Getty Villa (below) to the Getty Center in 1997.

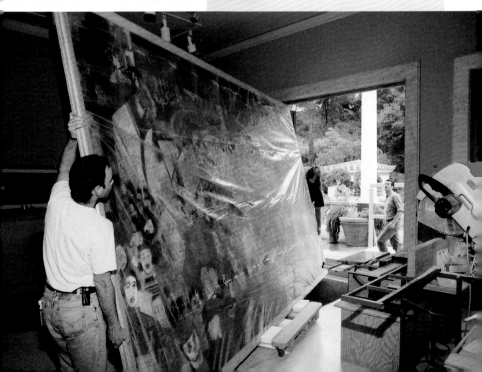

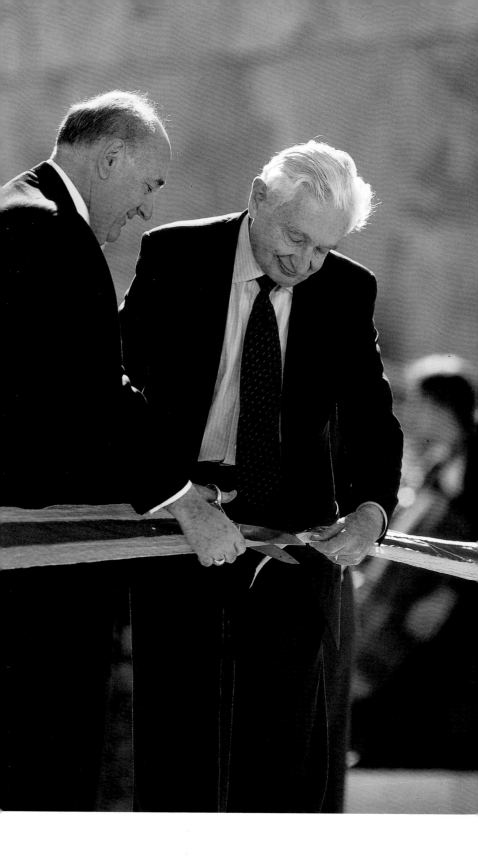

OPENING DAY The Getty Center officially opened to the public on December 16, 1997. Addressing the crowd of attendees at the dedication ceremony, Museum Director John Walsh said, "May this place give joy to you and your children and all the generations to come." Over 10,000 people arrived at the Getty Center on opening day.

Opening-week festivities included colorful giant puppets (inspired by the Getty Museum's painting *Christ's Entry into Brussels in 1889* by James Ensor) greeting visitors as they exited the tram, performances by the Crenshaw High School Elite Choir and the East L.A. band Los Lobos, and festive parties for neighbors, staff, and Trust leaders.

For everyone involved in planning and building the Getty Center and for all the employees of the Trust, the opening was a milestone to be celebrated. Fourteen years after the hilltop site was purchased, the Center was finally open. In its first week the Center received 47,514 visitors. Through April 2008, more than 14 million people have visited.

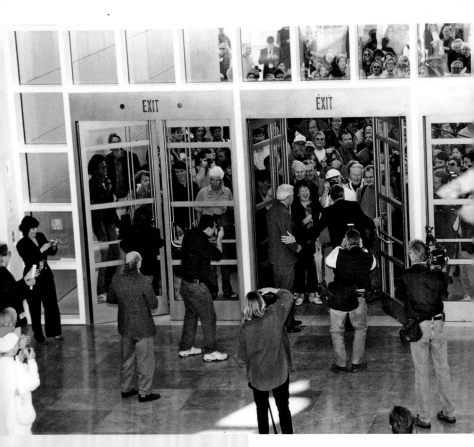

At left: Robert Erburu, Chairman of the Board of Trustees (left), and Harold Williams, Trust President and Chief Executive Officer (right), at the ribbon-cutting ceremony to inaugurate the opening of the Center. Above: Harold Williams (left) and Museum Director John Walsh (right) open the doors to greet the first public visitors to the Museum.

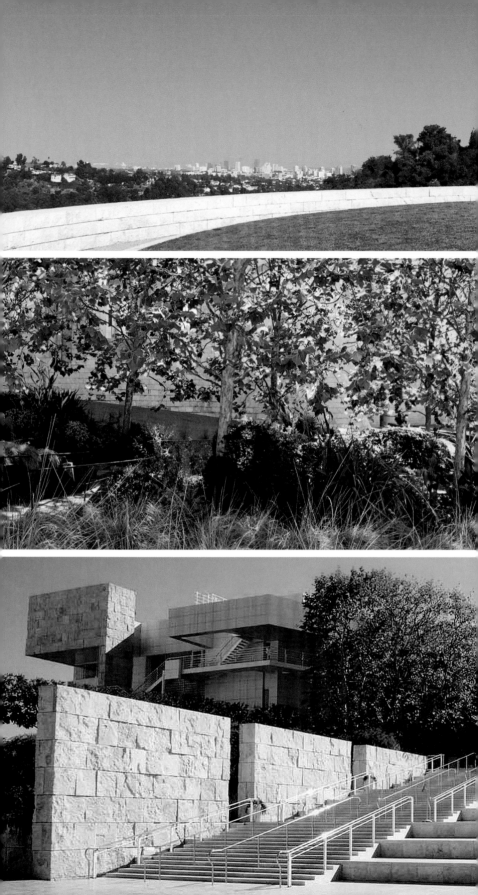

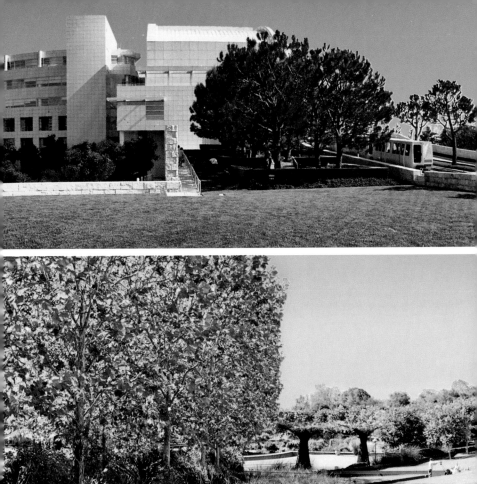

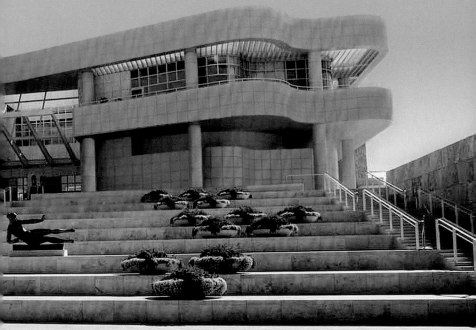

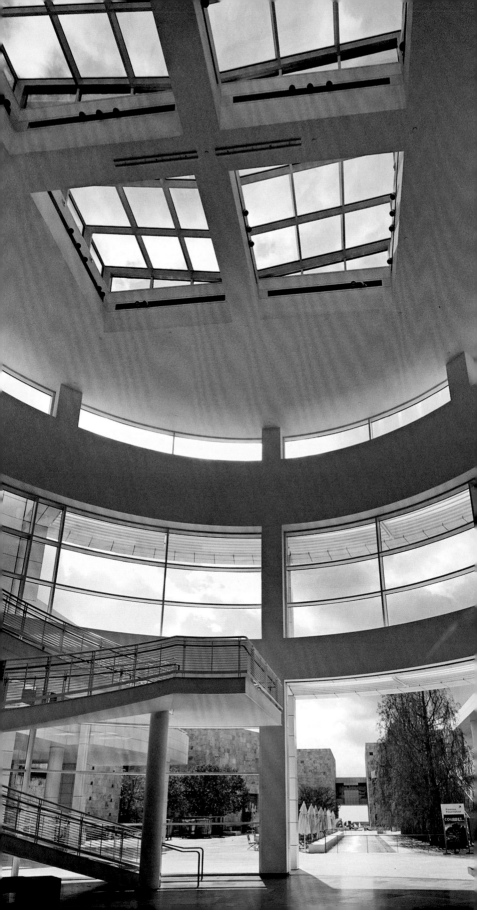

4 The J. Paul Getty Museum

FOUR LARGE TRAVERTINE-CLAD pavilions at the Getty Center house the Museum's permanent collection of European art from before 1900 and photographs and sculpture that date up to the present. Galleries for special exhibitions are on the upper floor of an additional pavilion. Visitors can walk from the Museum Entrance Hall directly to any of the pavilions. They are each two stories high and connect to one another by indoor and outdoor corridors that open up to sweeping vistas of Los Angeles. The galleries are organized by period and medium: a clockwise progression around the courtyard provides a chronological survey that begins in the thirteenth century and terminates in the nineteenth century (or, in the case of photographs, the twenty-first). Twentieth-century sculpture is placed throughout the site.

Paintings are exhibited in twenty galleries on the upper floors, where their viewing is enhanced by the natural lighting afforded by a complex system of louvered skylights. Illuminated manuscripts and drawings, which demand more carefully controlled lighting, are shown on the ground floors, as are decorative arts and most sculpture. Photographs are now displayed in the Center for Photographs, on the terrace level of the West Pavilion.

Despite Meier's staunchly modernist aesthetic, the galleries—which he designed with the participation of the New York architect and interior designer Thierry Despont—are traditionally proportioned rooms, supported by such classic elements as coved ceilings, colored walls, and wainscoting. Despont was also primarily responsible for the design of the fourteen decorative arts galleries, including four rooms with original eighteenth-century paneling.

The Museum Entrance Hall (left) at the Getty Center is a sixty-five-foot-high cylinder that evokes the rotundas in many classical buildings. It is highlighted by a dramatic spiraling staircase. Opposite the main doorway, a curved glass wall opens to reveal the Museum Courtyard and, around it, the separate pavilions that house the galleries. The Museum at the Getty Villa (above), inspired by an ancient Roman country house, now displays the antiquities collection.

ANTIQUITIES AT THE VILLA

The Museum's antiquities collection, now located at the Getty Villa, began with J. Paul Getty's purchase of a small terracotta sculpture at a Sotheby's auction in London in 1939. The thirty-seven years that passed between that acquisition and his last, the three-figure sculpture *Seated Orpheus with Two Sirens* (seen in the photo below), witnessed the formation of a collection of ancient Greek, Roman, and Etruscan art that was—and continues to be—one of the most important of its kind in the United States.

For many years the collection's greatest strength was in sculpture. It was the core of the collection when Getty was alive, and many of the Museum's most interesting examples of ancient sculpture were acquired under his personal direction. In the years since his death, the collection has grown considerably. The 1985 purchase of over 400 Greek vases and vase fragments from Walter and Molly Bareiss was a major addition. The accession of some 300 objects from the Bronze Age to late antiquity from the collection of Lawrence and Barbara Fleischman in 1996 and more than 350 striking pieces of ancient glass from the collection of Erwin Oppenländer in 2003 has substantially deepened the Museum's antiquities holdings.

The Temple of Herakles (right) was designed specifically to showcase the Lansdowne Herakles, which dates from the second century A.D.

Prehistoric objects (below), the oldest in the Museum's collection, were made by various cultures in the eastern Mediterranean and date from the Neolithic period to the end of the Bronze Age (ca. 6500–1000 B.C.).

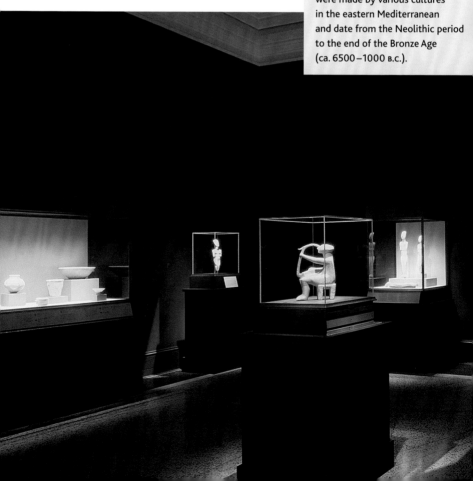

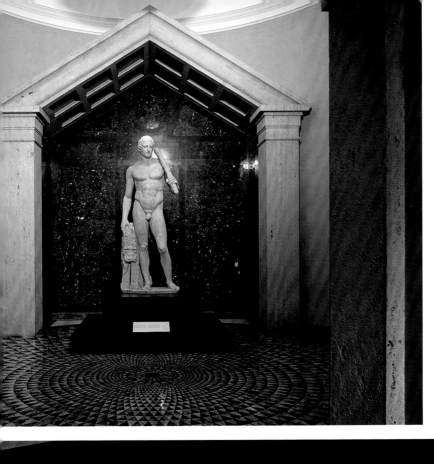

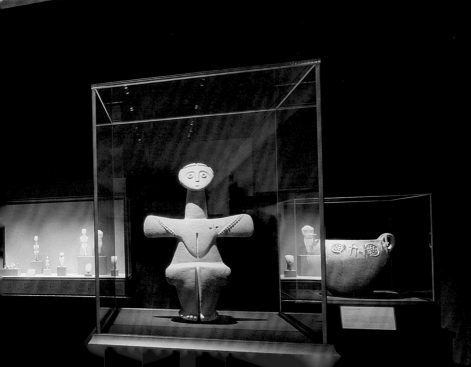

PAINTINGS

During his lifetime J. Paul Getty purchased paintings from every major European school of art between the fourteenth and twentieth centuries. He did not, however, consider himself a collector of paintings. His writings, especially his diaries, repeatedly name the decorative arts as his first love. Nevertheless, Getty began his painting and decorative arts collections at about the same time—during the 1930s. When he left the bulk of his estate to the Museum at his death in 1976, the opportunity presented itself to acquire major works on a wider scale. Since then, the Museum has added canvases from the seventeenth-century French and Dutch schools, the Impressionists and their successors, and eighteenth-century French painters, as well as small groups of important German and Spanish oils. These pictures, which number more than three-quarters of the paintings on exhibit, have significantly transformed the permanent collection galleries and given an overall balance to the holdings.

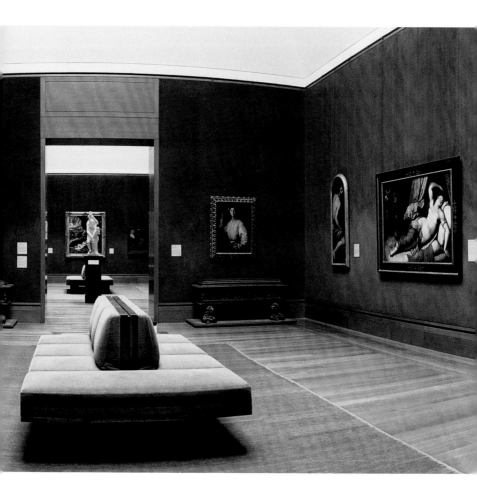

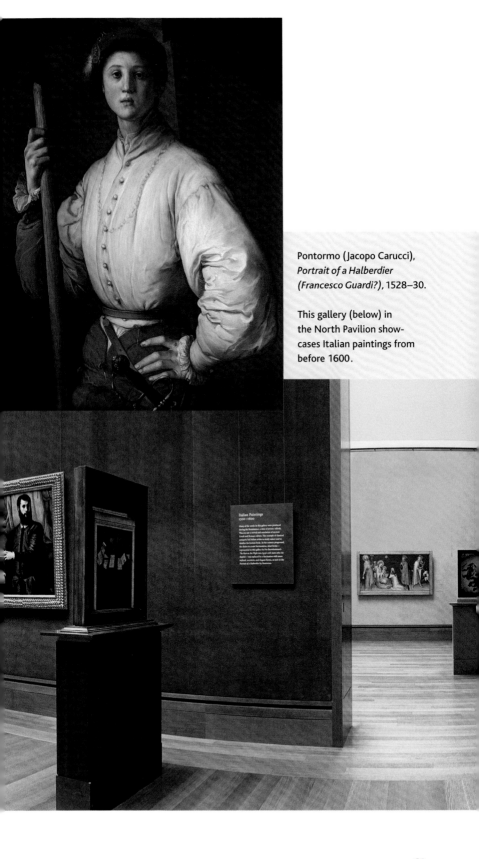

Pontormo (Jacopo Carucci),
*Portrait of a Halberdier
(Francesco Guardi?)*, 1528–30.

This gallery (below) in
the North Pavilion show-
cases Italian paintings from
before 1600.

IN THE GALLERIES

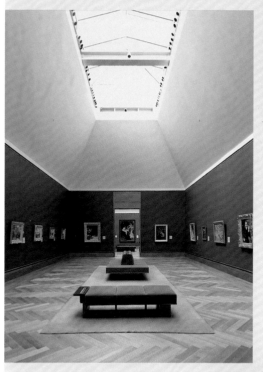

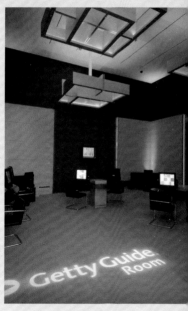

GETTYGUIDE STATIONS

The GettyGuide Room and computer terminals throughout the Museum can help visitors find works by specific artists or learn more about the collection in general.

GALLERY SKYLIGHTS

The skylights were built with computer-controlled louvers, which adjust to the position of the sun during the course of the day, ensuring optimum levels in the light's quality and intensity. There are also special filters to prevent damage to the artworks. Artificial lights are activated in late afternoon to maintain consistent illumination levels in the galleries after the sun has begun to set.

FRAMES HAVE STORIES TOO

The way a work of art is framed is an important part of the presentation and aesthetic experience. Frames and paintings must be matched to appropriate styles and periods. Antique frames are often purchased for this purpose. Some frames have been restored and some portions re-created based on historical reference material.

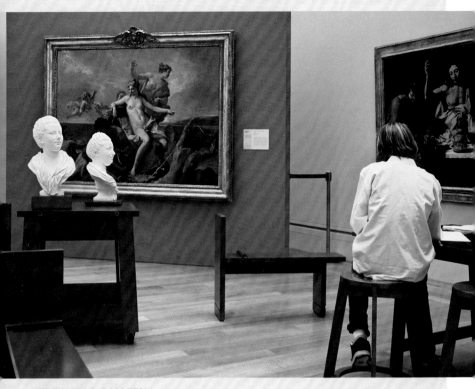

SKETCHING GALLERY
In this gallery, visitors can sketch from paintings and casts of sculptures from the Museum's collection.

SECURITY OFFICERS SPEAK MANY LANGUAGES
The security officers at the Museum collectively speak more than thirty different languages, including Bulgarian, Hindi, Ilocano, Farsi, Urdu, and Kiswahili.

SCULPTURE AND DECORATIVE ARTS

The sculpture and decorative arts collections were unified under a single department in 2004. J. Paul Getty had begun acquiring eighteenth-century French decorative arts in the 1930s, and today the holdings of objects made between 1650 and 1800 count among the Museum's finest. Included in this assemblage are furniture, silver, ceramics, textiles, clocks, and objects in gilt bronze. The European sculpture collection, comprising works made from the fifteenth through the nineteenth centuries, was formed in 1984 and has grown substantially in the representation of a wide range of sculptors and media. Renaissance and Baroque bronze, French eighteenth-century terracotta and marble, and British Neoclassical marble sculpture predominate. The Fran and Ray Stark Sculpture Collection, consisting of twenty-eight twentieth-century works, became part of the department's holdings in 2005.

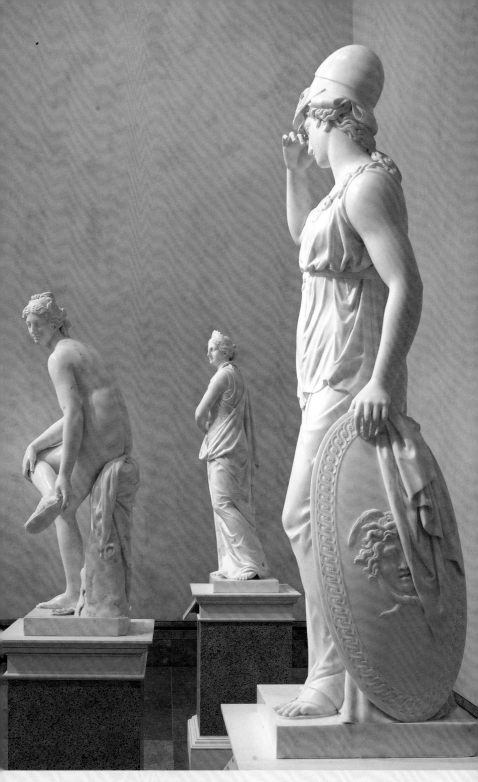

The above trio of marble, Neoclassical goddesses represent Juno, Minerva, and Venus. Although the figures have a cool remoteness, a powerful narrative engagement animates the group. At left is a detail of a bronze sculpture depicting the goddess Venus by followers of Jacopo Sansovino, ca. 1550.

This period room in the South Pavilion contains decorative arts from eighteenth-century France, including a wall clock, Turkish-style bed, mirror, commode, and wall lights.

A CLOSER LOOK

Looking closely at works of art can yield wonderful treasures, such as an artist's signature or thumbprint, a hidden compartment, or a tiny painting.

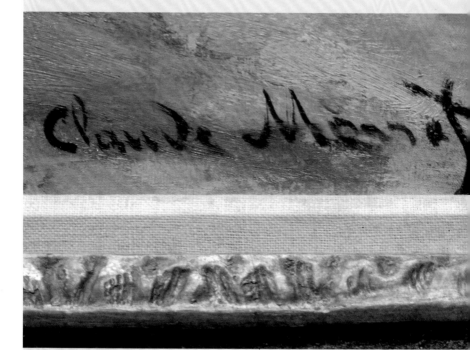

This painting bears the distinctive signature of the French Impressionist painter Claude Monet.

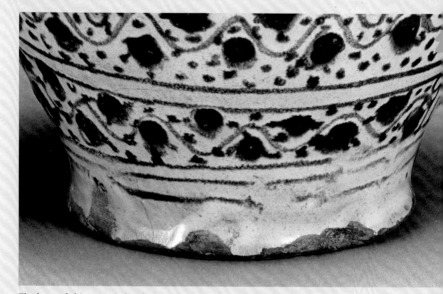

The base of this ceramic bowl contains impressions of its maker's fingers.

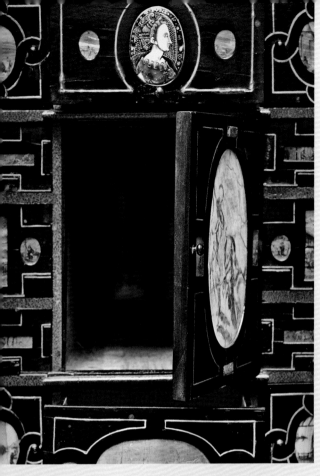

Cabinets often have secret doors or drawers, which are usually not opened while works are being exhibited. These features are valuable to scholars, conservators, and researchers because they reveal what the original colors looked like, since the exterior may have faded due to centuries of exposure to light.

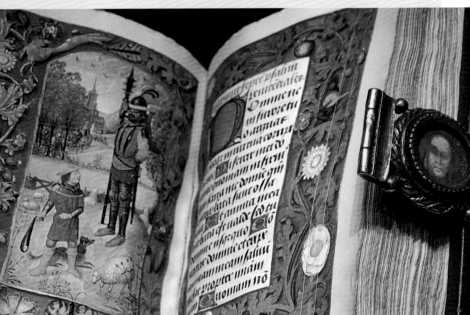

The clasp of this medieval prayer book holds a small round portrait.

DRAWINGS

The Museum began its collection of drawings in July 1981, with the purchase of Rembrandt's red-chalk study *Nude Woman with a Snake*. A year later, the Department of Drawings was formed. The collection now numbers more than

650 sheets, including two sketchbooks. The purpose of the collection is to assemble as representatively as possible the different schools of western European drawing and to illustrate the many varied techniques and styles achieved in the medium.

As drawings are sensitive to light and may deteriorate after prolonged exposure, they cannot be exhibited for an extended period. Those on display at any given time are usually selections from the collection brought together in order to illustrate a common theme or a particular period within the history of art.

Rembrandt van Rijn, *Nude Woman with a Snake* (left), ca. 1637.

Paul Cézanne, *Still Life* (right), ca. 1900, shown informally in a storeroom.

A view of the drawings galleries, located in the Museum's West Pavilion.

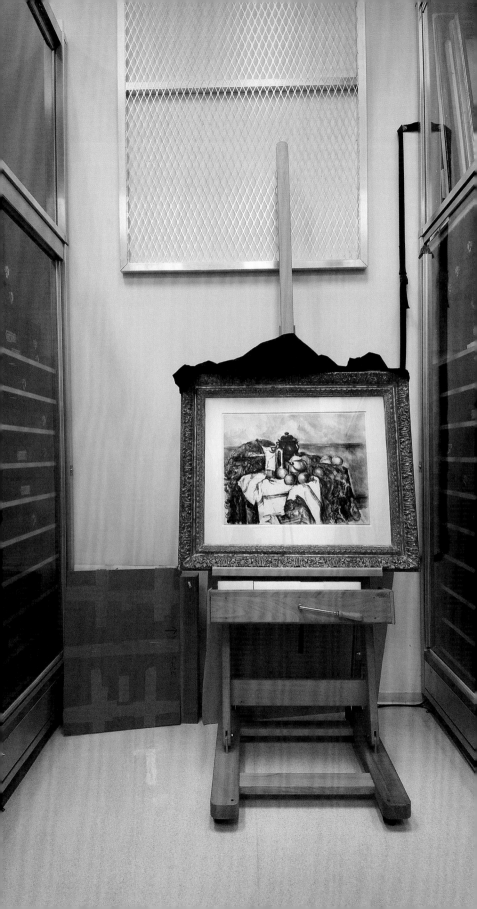

MANUSCRIPTS

The artistic impulses of medieval and Renaissance painters often found their purest expression in the pages of manuscripts, books written and decorated entirely by hand. In 1983 the Museum initiated the collection with the purchase of the holdings of Dr. Peter and Irene Ludwig of Aachen, Germany. Almost one hundred further acquisitions have been made since 1984, including entire codices as well as cuttings or groups of leaves from individual books.

The Getty's manuscript collection comprises masterpieces of Ottonian, Byzantine, Romanesque, Gothic, International Style, and Renaissance illumination from Germany, France, Belgium, Italy, England, Spain, Poland, and the eastern Mediterranean. The Getty provides one of the most ambitious programs in the world for the display of illuminated books and exhibits manuscripts on a rotating basis year-round. Like drawings, manuscripts must be shown in low-light conditions due to their fragility.

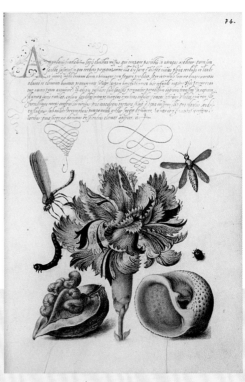

A researcher examines Martín de Murúa's *Historia general del Pirú* (1616) (above). Illuminated manuscripts—some created more than a thousand years ago—require special lighting when exhibited to preserve their delicate contents (left).

Joris Hoefnagel, from *Mira calligraphiae monumenta*, ca. 1591–96.

PHOTOGRAPHS

In mid-1984 the Museum established a new curatorial department dedicated to the art of photography, simultaneously acquiring the collections of Samuel Wagstaff, Arnold Crane, Bruno Bischofberger, André Jammes, and Volker Kahmen/George Heusch. These holdings, along with other key accessions made at the same time, have brought to Los Angeles the most comprehensive body of photographs on the West Coast. The Getty's collection includes significant works from the dawn of the medium to the present. The collection houses more than 30,000 individual prints, 1,500 daguerreotypes, 30,000 stereographs and cartes-de-visite, and 475 albums containing almost 40,000 mounted photographs.

William Henry Fox Talbot, *Leaves of Orchidea*, 1839.

The Center for Photographs, which opened in 2006 in the Museum's West Pavilion, has seven thousand square feet of display space in its galleries, making it one of the largest venues devoted to photographs in North America.

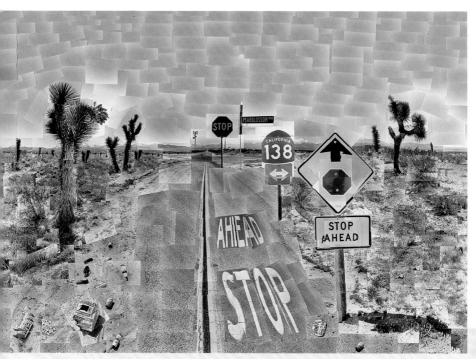

David Hockney, *Pearblossom Hwy., 11–18th April 1986, #2*, 1986.

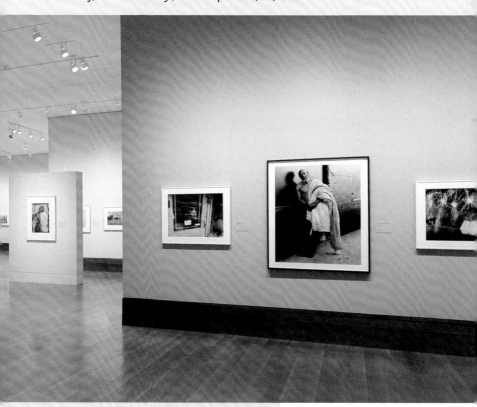

Where We Live: Photographs of America from the Berman Collection, which opened on October 24, 2006, was the first exhibition in the Center for Photographs.

DUSTING EVERY WEEK

Every object on display in the Museum is dusted once a week when the galleries are closed. Special care must be taken not to scratch or abrade any surfaces during cleaning. Special brushes and other tools are used.

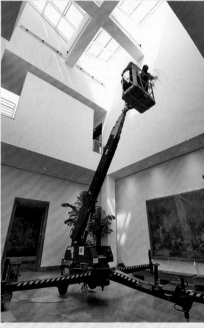

FIRM SUPPORT

In many instances the cushions of chairs are replaced with a block of foam to give the upholstered fabric a firm shape. The seats, therefore, may not be as comfortable as they look.

COMPLEX HOUSEKEEPING

Special equipment is brought into the galleries to access difficult-to-reach spaces. The painting in the photograph is covered with plastic to protect it while staff members touch up paint in the upper atrium.

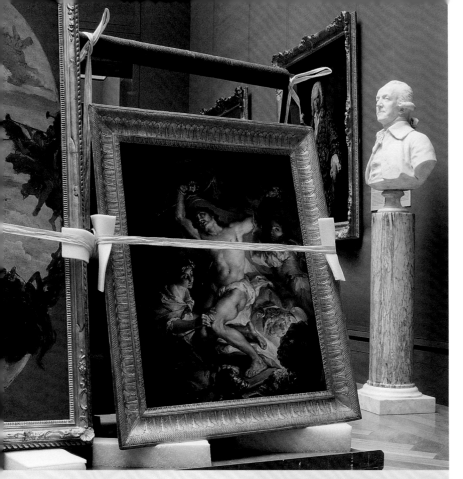

ALWAYS PROTECTED

Works of art must always be protected, not just when they're secured to the wall but during transportation, installation, and storage as well. Paintings being moved through the galleries are strapped to a cart (above), and a table in storage (right) is secured to a platform that has cushioned pads to absorb the vertical movement of an earthquake.

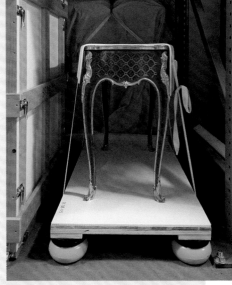

VAULTS FOR STORAGE

The Museum has is more than twelve thousand square feet of storage space for paintings, sculpture, decorative arts, and works on paper.

MUSEUM CONSERVATION LABORATORIES

Conservation is central to the Museum's mission. The four conservation departments—paintings, sculpture and decorative arts, paper, and antiquities—occupy specially equipped studios at both the Center and the Villa. Staff conservators combine the most current scientific information about materials with extensive knowledge of and proficiency in centuries-old art-making techniques and processes. Museum conservators work in concert with the Getty Conservation Institute's Museum Research Laboratory, which conducts scientific analysis of works from the collection and studies technology and materials.

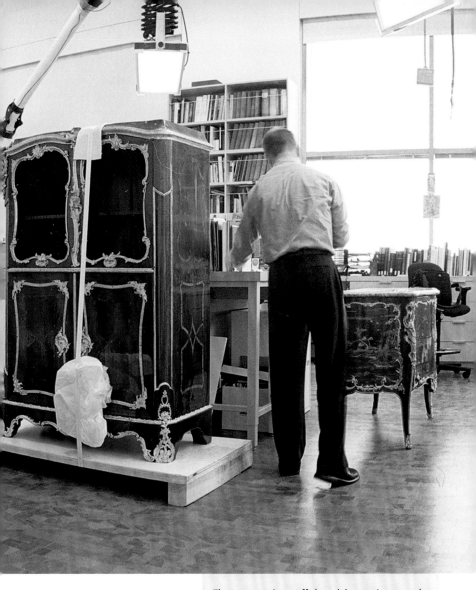

The conservation staffs have laboratories to work on treatments for the objects in the Museum collection and in collaboration with other institutions. Analyzing materials, stabilizing, cleaning, and restoring are all activities undertaken before a work can be exhibited. Here, in the decorative arts conservation lab, a conservator prepares to work on an eighteenth-century French cabinet in the Museum's collection.

Conservation also entails employing important preventive measures. These include climate control and environmental monitoring, design of mounts and display cases, pest management, and improving storage, packing, and shipping methods. Mitigating the effects of earthquakes is a particular challenge in California, and the Museum is recognized around the world for the solutions it has developed and published to address this problem.

CONSERVING WORKS OF ART

Conservators are like doctors for works of art. They wear gloves, often use cutting-edge technology to determine treatment, and have been known to bring a "patient" back to life. For Museum conservators, this might be a magnificent painting, a rare cabinet, a priceless silver bowl, or a delicate illuminated manuscript. Conservators support the Museum's efforts to preserve works of art for the enjoyment and education of future generations.

A scientist studies a material sample through a laser ablation ICPMS (inductively coupled plasma mass spectrometer) in the Getty Conservation Institute lab at the Getty Villa.

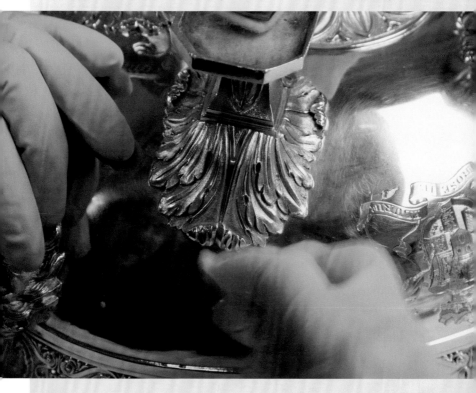

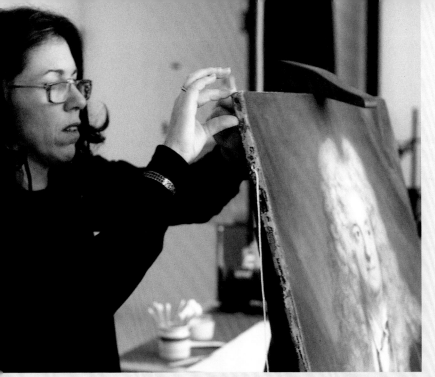

A museum conservator repairs edge tears to a pastel, Joseph Vivien's *Portrait of a Man*.

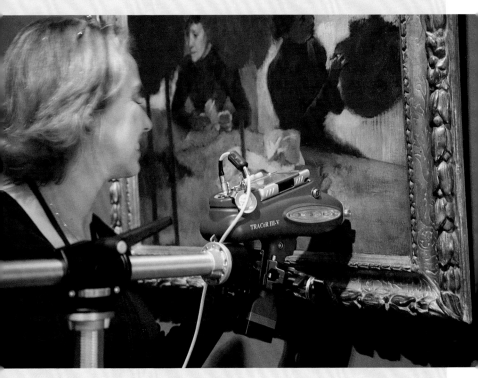

A Conservation Institute scientist examines Edgar Degas' painting *The Milliners* with the aid of an infrared spectrometer, used to analyze the chemical components found in the paint.

A conservation intern cleans a silver tureen in the Museum's decorative arts collection.

EDUCATION

Educational programming at the J. Paul Getty Museum embodies the principle that if visitors know more about works of art, they can more deeply enjoy them and relate the works to their own experiences. The Museum's Education Department offers a range of programs for diverse audiences, including families, students, teachers, art professionals, and general visitors.

The Museum contains dedicated spaces and resources at both the Center and the Villa for educational opportunities. Daily talks, artist-run workshops and demonstrations, tours of the architecture and gardens, and lectures on the collection and special exhibitions provide engaging ways for visitors of all ages to learn about art. At the Center, the Family Room offers innovative activities for children and their parents to share, while the Villa's Family Forum provides ways for young and old alike to explore ancient art.

At left: A school group at the Center engages in an activity inspired by Georges de La Tour's painting *The Musicians' Brawl*. At right: The Villa's Family Forum provides a fun, hands-on space for families to learn more about antiquities.

PUBLICATIONS

Furthering J. Paul Getty's wish to promote "the diffusion of artistic and general knowledge," the Museum also publishes, on average, thirty books each year, ranging from exhibition catalogues and children's titles to scholarly publica-

tions and reference volumes. The Publications Department, comprised of forty-eight staff members, oversees the editing, design, production, marketing, sales, and distribution of Getty books.

Getty Publications produces a wide range of books on many topics for audiences of all the Getty programs (below). Books print domestically and internationally, depending on the budget, schedule, and quality required of each project. A series of special silk-screened volumes were printed in India (at left).

SPECIAL EXHIBITIONS AT THE GETTY

Both the Getty Center and the Getty Villa have hosted numerous temporary exhibitions that complement the Museum's collection areas and those of the Research Institute as well as the work of the Conservation Institute. At the Center, the seven-thousand-square-foot Exhibitions Pavilion has housed all manner of art media and epochs, including rarely seen medieval icons from Sinai, large-scale contemporary video pieces by Bill Viola, Flemish illuminated manuscripts of the Renaissance, the late religious portraits of Rembrandt, interactive devices from the 1600s, the sculptures of Houdon, and the work of photographers from the 1800s and 1900s. Since the Villa's reopening, galleries for changing exhibitions have featured Athenian vases, North African mosaics, and photographs of ancient sites. Special exhibitions at the Getty allow the Museum to collaborate with institutions around the world and tell a more complex narrative about the history of art.

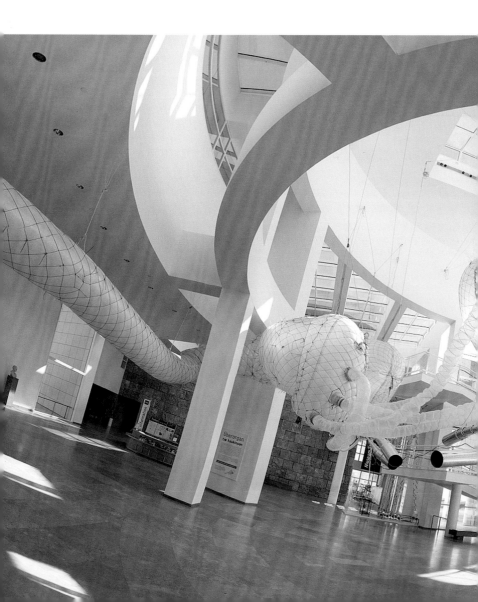

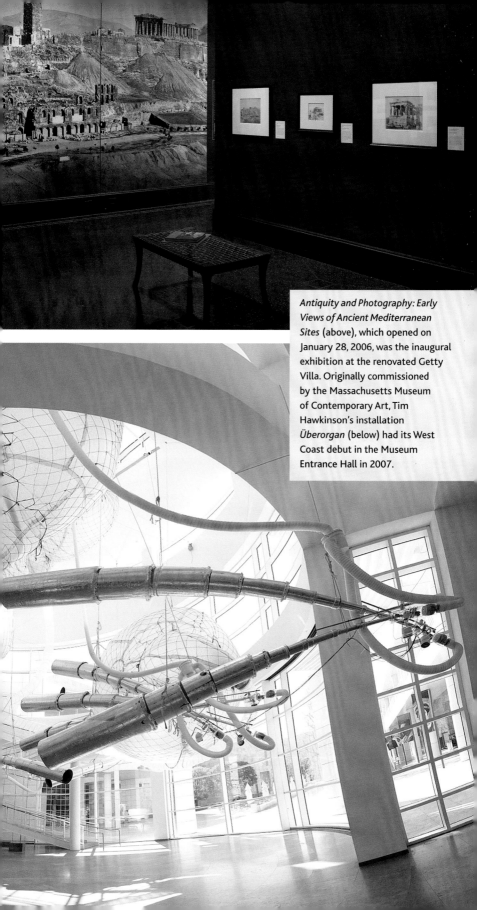

Antiquity and Photography: Early Views of Ancient Mediterranean Sites (above), which opened on January 28, 2006, was the inaugural exhibition at the renovated Getty Villa. Originally commissioned by the Massachusetts Museum of Contemporary Art, Tim Hawkinson's installation *Überorgan* (below) had its West Coast debut in the Museum Entrance Hall in 2007.

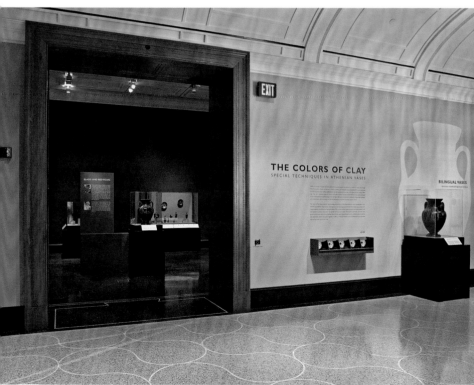

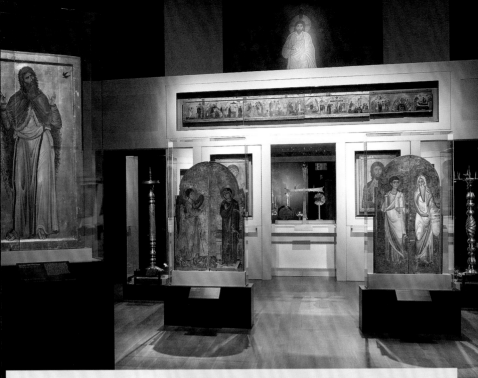

Devices of Wonder: From the World in a Box to Images on a Screen (opposite top), a 2001 collaboration between the Museum and the Research Institute shown in the Center's Exhibitions Pavilion, featured over four hundred objects from the 1600s to the present. The Colors of Clay: Special Techniques in Athenian Vases (opposite bottom) at the Getty Villa in 2006 presented exquisitely potted vases. Holy Image, Hallowed Ground: Icons from Sinai (above) showcased rarely seen Byzantine icons from the Holy Monastery of Saint Catherine in Egypt. The exhibition was on view in the Exhibitions Pavilion from November 2006 through March 2007. At middle, an invocation ceremony for the exhibition opening and below, a blessing led by monks from the monastery.

PLANNING AND INSTALLING AN EXHIBITION

Putting on an exhibition calls upon the expertise of virtually every department in the Museum.

The initial idea for an exhibition usually comes from a curator, who chooses which works of art will be shown. If works are being borrowed from other institutions, loan request letters are sent out. Approximately a year and a half before an exhibition opens, a team is assembled, consisting of members from numerous departments: curatorial, exhibition design, registrarial, preparations, conservation, education, publications, communications, museum store, security, interactive programs, exhibitions, and Web production. In the months leading up to the exhibition, loans for works of art are finalized; the design of the exhibition is decided upon; didactic texts and labels are written and edited; a catalogue is produced; conservation work, if necessary, is undertaken; opening and press events are organized; and, finally, the artworks are received and installed in the galleries. Through this collaborative and creative ferment an exhibition comes together.

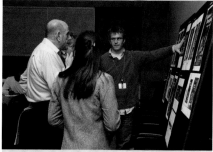

The following sequence of pictures focuses on the 2006 exhibition *Rubens and Brueghel: A Working Friendship*, held at the J. Paul Getty Museum at the Getty Center and organized in partnership with the Royal Picture Gallery Mauritshuis, The Hague. The show explored the collaboration between two seventeenth-century Flemish painters, Peter Paul Rubens and Jan Brueghel the Elder.

EXHIBITION PLANNING

Planning for an exhibition can begin many years in advance of the opening. As that date approaches, staff teams meet often to review schedules, budgets, logistics, and any special requirements. Meetings are also convened to review exhibition plans, graphics, and promotional and educational components. A miniature mock-up (third from top) of the show helps to visualize the placement of works.

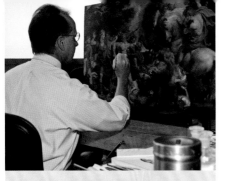

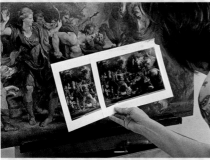

DOCUMENTING WORKS OF ART

After any required conservation is completed on a Getty object or, under special circumstances, a loaned object, the artwork is then digitally documented. Prints are created and compared to the original work to ensure the best possible color match. These images can be used in publications or marketing materials related to the exhibition.

CONSTRUCTION

For major loan shows such as *Rubens and Brueghel*, paintings are sent from all over the world in special crates. The works of art are then unloaded, inspected, and recorded by the Registrar's Office. Once the design and installation plans are approved, the in-house construction staff begins to build cases, employ special mounting devices, and select options for covering display surfaces.

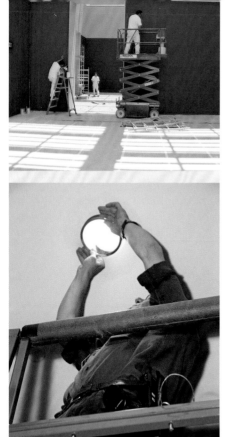

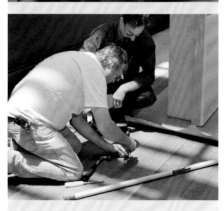

GALLERY PREPARATION

Gallery spaces are customized for each exhibition, including building and painting walls, setting up lighting, and installing cases. All this must be completed before any works of art are allowed into the galleries, to ensure against damage.

INSTALLING GRAPHICS

In the galleries the photo murals, didactic texts, and labels are installed, all having been written in the respective curatorial departments, designed in the Museum's Exhibition Design Department, and vetted by the Museum's education and editorial staffs.

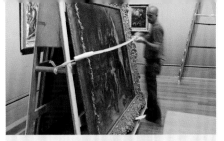

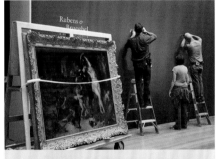

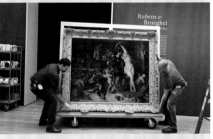

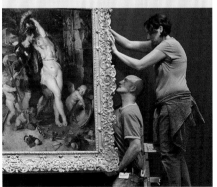

MOUNTING WORKS OF ART

Works of art are secured to dollies and moved to the exhibition gallery. Large elevators are used to move oversize works. The staff preparators are trained to handle and install the works with the care that priceless objects deserve.

PROMOTION

Outdoor signage announces the show to vistors and directs them to the galleries. Street banners are also hung around the city to promote special exhibitions. Once the exhibitions are over, some banners are recycled, made into tote bags, and sold in the Museum Store.

PUBLIC PROGRAMS

Day and night, there is usually something going on at both the Getty Center and Getty Villa. The two campuses offer numerous public programs, including tours and gallery talks, lectures and conferences, courses and demonstrations, family and school activities, and readings and book signings. The Center's busy performance and film schedule includes the annual series Friday Nights at the Getty, featuring music, dance, theater, and spoken-word events; Selected Shorts, with noted actors reading classic and new short fiction; and Gordon Getty Concerts, which showcase world-class musicians in performances that complement exhibitions at the Center. At the Villa, musical and dramatic performances related to the ancient world are held in the Auditorium or the Fleischman Theater. Recent productions have included modern interpretations of such Greek classics as Aeschylus's *Oresteia*, Aristophenes' *The Birds*, and Euripides' *The Bacchae* and *Hippolytos*.

A 2005 Selected Shorts performance (above) at the Harold M. Williams Auditorium at the Getty Center featured (left to right) Alec Baldwin, Steven Gilborn, Dawn Akemi Saito, and Michael York. At the podium is Isaiah Sheffer, director and host of Selected Shorts. Euripedes' Greek tragedy *Hippolytos* (right) inaugurated the Getty Villa's Fleischman Theater in September 2006.

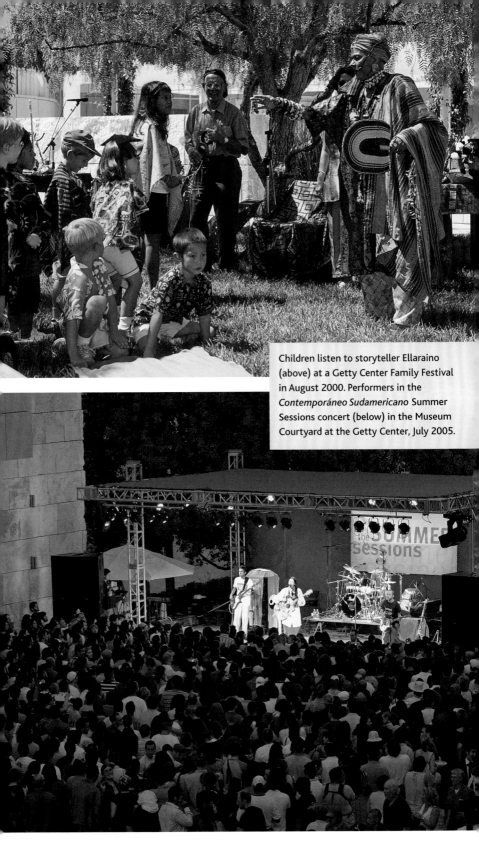

Children listen to storyteller Ellaraino (above) at a Getty Center Family Festival in August 2000. Performers in the *Contemporáneo Sudamericano* Summer Sessions concert (below) in the Museum Courtyard at the Getty Center, July 2005.

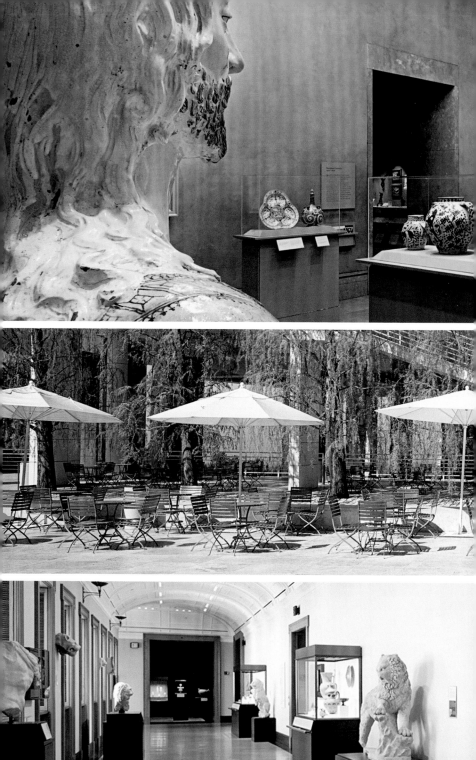
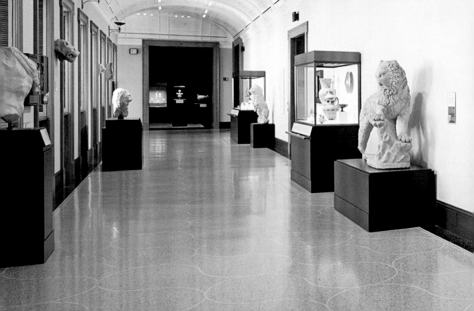

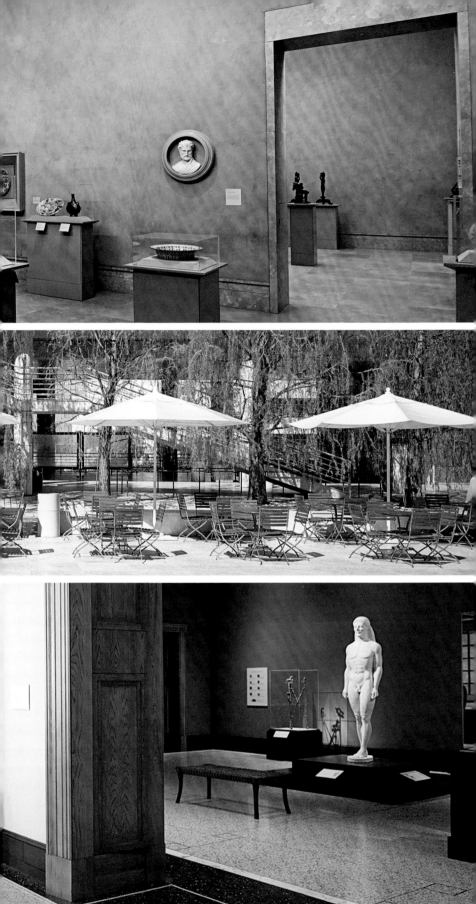

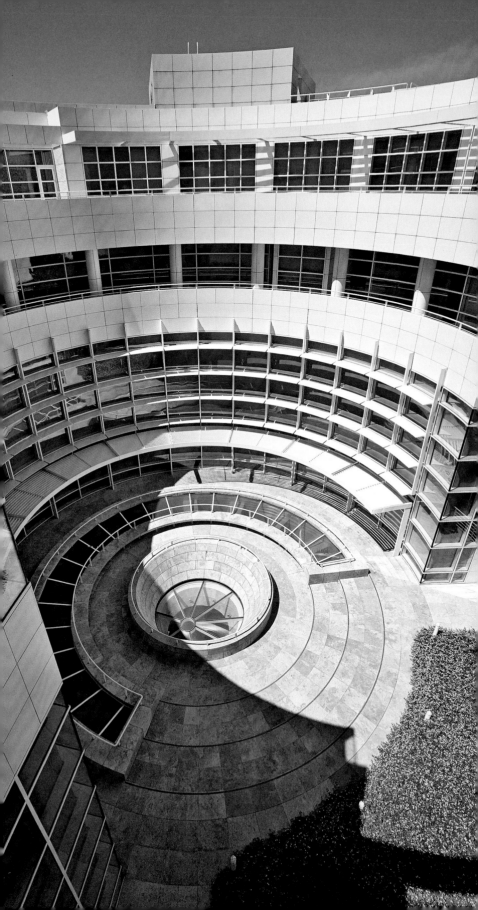

5 The Getty Research Institute

DEDICATED TO STUDYING THE VISUAL arts in broad historical and cultural contexts, the Getty Research Institute provides a unique setting for scholarly investigation and debate. The Research Institute's foundation lies in the special collections of original documents and objects from the Renaissance to the present, held in its vast library.

The Research Institute's international residential scholar program each year brings together some of the best minds from all disciplines, including creative artists, to address and debate themes of particular urgency. Publications, both print and electronic, disseminate the work of the Institute and foster innovative research wherever it is found. Exhibitions, conferences, workshops, and lectures give compelling expression to inventive scholarship and thought.

The circular Research Institute building occupies 201,000 square feet arranged on five levels and houses the library, meeting facilities, an exhibition gallery, lecture hall, and offices for over two hundred scholars and staff. Its flexible design encourages an open exchange of ideas and discoveries.

THE RESEARCH LIBRARY

The Research Library at the Getty Research Institute is one of the largest art libraries in the world. It focuses on the history of art, architecture, and archaeology, with relevant materials in the humanities and social sciences. The general library collections (secondary sources) include more than one million books, periodicals, and auction catalogs. The range of the collections begins with prehistory and extends to contemporary art.

The Photo Study Collection contains approximately two million photographs of art and architecture from the ancient world through the twentieth century. The Research Institute's online databases provide essential resources for scholars, librarians, and museum professionals all over the world. The Research Library also contains the Getty's Institutional Archives, which document the Getty's founding and development.

At the Getty Villa, the Research Library is a twenty-thousand-volume-capacity annex, housed in the Ranch House, where scholars can conduct research related to Greek and Roman culture and history.

A view of the Research Institute's oculus, which admits sunlight into the lower level and is the building's geographical center.

SPECIAL COLLECTIONS

The library's special collections contain rare books and unique materials such as personal papers, journals, letters, sketchbooks, and other archival documents. Artists' papers and archives include a volume of drawings by the fifteenth-century artist Francesco di Giorgio Martini; a bound album of

drawings made in Italy by the great French Neoclassical painter Jacques-Louis David, selected and pasted in by the artist; and the first full draft of *Noa Noa* by Paul Gauguin, written in 1893, during his stay in Tahiti.

The twentieth century is especially well represented, with archives of major figures in Dada, Surrealism, Futurism, and other avant-garde movements from early in the century, as well as important materials on Fluxus, Conceptual Art, Minimalism, and related developments in the postwar period. The collection of video art, which includes the most extensive holding of such works produced in Southern California, is one of the largest in the world. There are also more than five thousand contemporary artists' books.

Modern architecture is another strength. There are sketches, notes, and unpublished manuscripts by Le Corbusier and others associated with the Bauhaus; drawings by Frank Gehry for Los Angeles's Walt Disney Concert Hall; and over 260,000 negatives, prints, transparencies, and related materials from the archive of Julius Shulman, who photographed modern architecture in postwar Southern California.

Inventories and catalogues of private collections and museums and the archives of collectors, dealers, and galleries shed light on the business of art and the history of collecting. The library holds the papers

Giovanni Battista Piranesi, *Veduta del prospetto principale della Colonna Trajana* (detail), etching in *Trofeo o sia magnifica colonna coclide di marmo composta di grossi macigni ove si veggono scopite le due guerre daciche fatte da Traiano...* (Rome, 1774–79). 90-B22638

Marcel Duchamp, *Boîte en valise*, 1958, mixed media. Jean Brown papers, 890164

Julius Shulman, *Zimmerman House by John Lautner, Studio City, California* (1968), photographed 1980, gelatin silver print. Julius Shulman photography archive, 2004.R.10

Bernard Picart, *Convoi funebre d'un grand de la Chine*, etching in *Ceremonies et coutumes religieuses de tous les peuples du monde* (Amsterdam, 1729). 1387-555

Francesco di Giorgio Martini, *Construction Machines*, ca. 1475–ca. 1480, brown ink and wash. In manuscript *Edificij et machine*, fol. 27. 870439

Jackie Matisse Monnier, *Underwater Kite, Nassau, Bahamas*, for *Sea Tails*, 1983. Jackie Matisse Collection. Photograph © Robert Cassoly. David Tudor papers, 980039

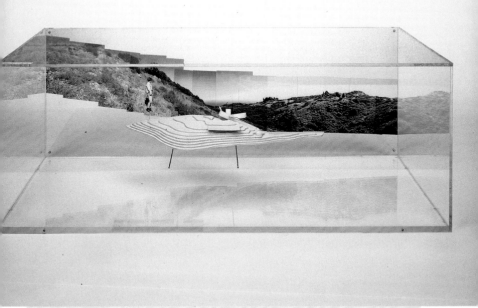

Coop Himmelb(l)au, *Model #15 (Rehak House, Malibu, California)*, 1990–ca. 1995, foam core, paper, wire, and photographic Mylar mounted on Plexiglas sheet inside case. 2002.M.2

of the late Marcia Tucker, founding director of New York's New Museum of Contemporary Art; invoices and ledger and stock books from Duveen Brothers, among the most important dealers in the world for much of the twentieth century; and the archives of Count Giuseppe Panza, whose collections provided a foundation for the Museum of Contemporary Art, Los Angeles.

There are rare books, manuscripts, and archives from influential scholars such as Johann Joachim Winckelmann who helped shape the discipline of art history; Nikolaus Pevsner, a pioneer in the field of architectural history; and twentieth-century critics Clement Greenberg and Harold Rosenberg.

The special collections also include travel guides, photographs of archaeological monuments and international expositions, and historic maps of important cities. Additionally, there are optical devices and games that prefigured such modern developments as photography and motion pictures.

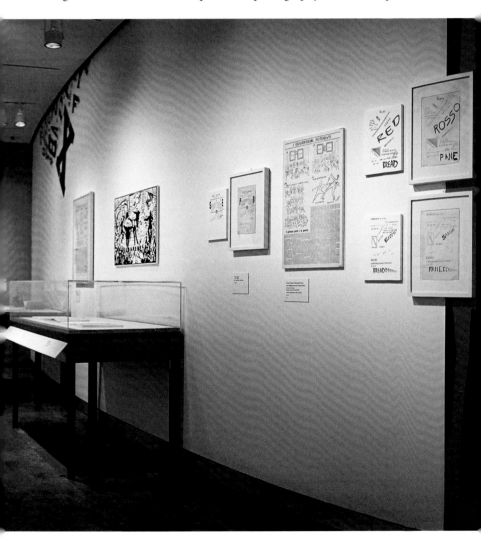

EXHIBITIONS

Exhibitions at the Research Institute are designed to showcase the rare and unique materials in the Research Library's collections. These presentations provide a pathway into, and represent all periods in, the collections—from classical to contemporary—with an eye toward critical analysis and reinterpretation. Curators include Institute staff and outside scholars and artists.

The exhibitions are displayed in the gallery on the Plaza Level of the Research Institute. Three shows are presented each year. Exhibitions are occasionally developed by Research Institute staff for the major temporary exhibition spaces at the J. Paul Getty Museum at the Center and Villa.

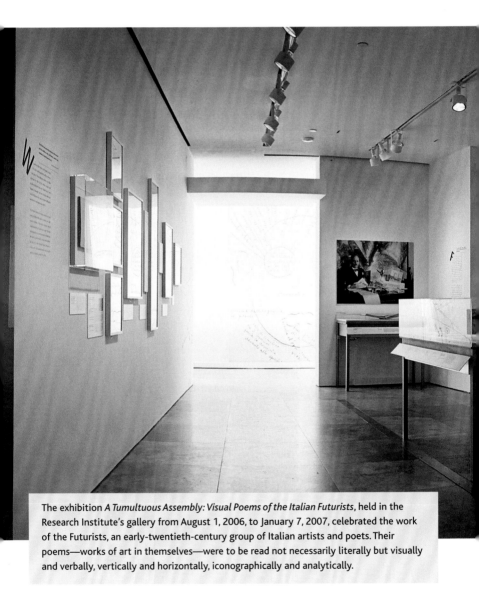

The exhibition *A Tumultuous Assembly: Visual Poems of the Italian Futurists*, held in the Research Institute's gallery from August 1, 2006, to January 7, 2007, celebrated the work of the Futurists, an early-twentieth-century group of Italian artists and poets. Their poems—works of art in themselves—were to be read not necessarily literally but visually and verbally, vertically and horizontally, iconographically and analytically.

PROGRAMS

The Research Institute offers a broad range of public programs—including lectures, panel discussions, performances, and film screenings—for diverse audiences. Many of these events are presented in collaboration with other Los Angeles institutions. Past programs have explored connections between dance and the visual arts and between architecture and music. Many events

are followed by discussions with artists, architects, filmmakers, choreographers, and critics, among others. A popular series focuses on the history of the Los Angeles art scene.

Photographer Julius Shulman (at right) in conversation with Research Institute curator Wim de Wit about Shulman's work and the Research Institute exhibition *Julius Shulman: Modernity and the Metropolis*, October 2005.

"Feel Like Going Home: Musicians in Print, on Film, and in Concert" panelists (left to right) Thomas Crow, then director of the Research Institute, and authors Robert Gordon, Gerri Hirshey, and Peter Guralnick discuss music and biography, May 2003.

Members of the LA Art Girls (below) in "An Evening of Short Performances" at the Harold M. Williams Auditorium, presented in conjunction with the "Movement and the Visual Arts" conference organized by the Research Institute, June 2006.

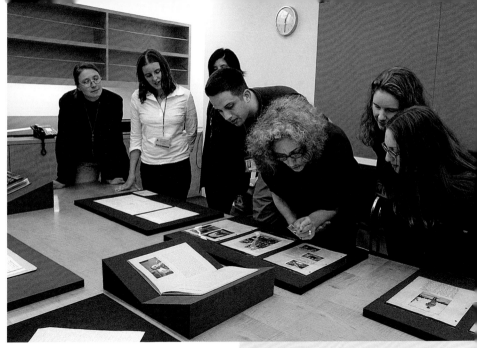

SCHOLARS

The Research Institute provides support for scholars at the senior and pre- and postdoctoral levels. Academicians, artists, architects, composers, filmmakers, and writers come from around the world to work on their own projects as well as participate in semi-

Getty residential scholar Sally Stein, associate professor of art history at the University of California, Irvine, leads the Research Institute's first graduate consortium seminar, "Biography in Visual Studies: Contested Theories and Practices," which coincided with the 2002–3 research theme of "Biography."

Echoing the building's shape, a ramp (left) connects the public reading room to the Research Library reference desk.

nars and other aspects of the intellectual life of the Getty. Getty scholars are in residence at the Center or the Villa, where they pursue their own work, make use of Getty collections, and join their colleagues in talks and discussions devoted to the year's scholarly theme.

PUBLICATIONS

The Research Institute's publications advance critical inquiry in the visual arts, promoting experimental and multidisciplinary investigations. Series emphasize scholarship and research emerging from the Institute's conferences, workshops, and seminars and make available primary materials from its special collections. The Research Institute also publishes previously unavailable or untranslated works and new editions of landmark books of modern scholarship.

CONSERVATION

Because many of the works in the Research Library's special collections have a unique character, the staff must possess expertise in a wide range of areas. This might involve the reconstruction and preservation of delicate architectural models to making mounts for exhibitions of rare books to conserving correspondence dating to the Renaissance.

Unlike the works of art in a museum, objects in special collections are regularly handled by scholars who have come to study them, and must therefore be able to withstand frequent exposure to air, light, physical movement, and human contact. The most fragile items are protected from overuse through microfilming and digitizing, making it possible for scholars and researchers to study these sources while preserving the works themselves.

The Research Library's holdings present a host of conservation challenges. Many artists, from the mid-twentieth century onward, have turned to unorthodox materials and modern media to create their works. The archives of artists and collectors often include films, videos, Polaroid photographs, and architect's models, which can be made of wood, metals, resins, and other, newer synthetic materials. Additionally, scholars are eager to examine and interpret these unconventional items, which are available in few other library holdings. Such complex objects, often damaged or dismantled over their lives prior to entering the Research Library, demand precise detective work, painstaking craft, and scrupulous recording of the restoration process on the part of conservators.

Physical deterioration of any kind can erase an object's record of its time, place, and conditions of construction. Conservation is a critical link in the chain of knowledge production. When a fragile piece is needed by a scholar or is slated for exhibition, it moves to the head of the line for treatment, in the course of which new information often comes to light.

ARCHITECTURAL MODELS

The special collections include more than one hundred architectural models. Many of these were quickly constructed and not meant to survive much longer than the time needed to realize an architectural commission. Here a conservator treats a model made by the architect Daniel Libeskind.

HANDLING AND TREATMENT

As the bulk of the Institute's collection materials exist for the purpose of being studied and handled by researchers, it is crucial that the materials be evaluated and treated for durability. This may include ridding a rare book of mold spores (above) or using a spectrodensitometer (left) to measure an object's density and color values. Conservators work in specially equipped labs (below) to carry out their work.

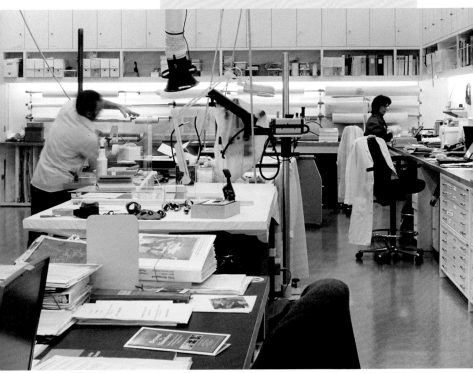

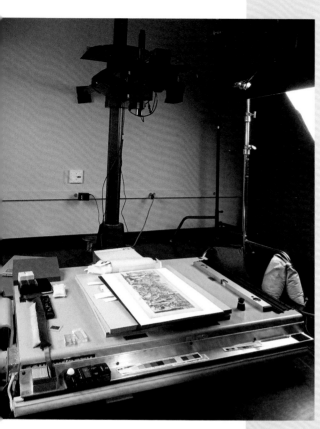

DOCUMENTATION

The process of repair and restoration also entails the creation of an archival photographic record (left)—a high-resolution document that can be used in any number of digital applications. In this way, one unique object can have many uses in a worldwide network of communication and information sharing. The documentation process can often extend to creating facsimiles of books or manuscripts when the originals are too fragile for loan or display.

STORAGE

The Research Institute is equipped with twenty-six linear miles of shelving (below) for its ever-expanding general collections and rare books, photographs, prints, drawings, and archival materials. In the Institute's cold-storage facility, staff must wear parkas (right).

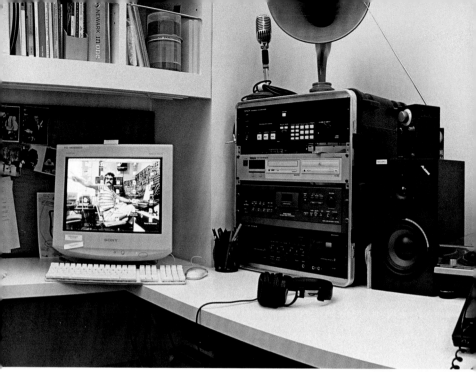

FILM AND VIDEO COLLECTION

The Research Institute is now home to one of the largest institutional collections of film and video art in the world after the acquisition of the vast Long Beach Museum of Art video archive in 2006. This addition of nearly five thousand tapes—including pieces by pioneering video artists such as Nam June Paik, Joan Jonas, John Baldessari, and Bill Viola—bolsters the Institute's holdings of video work in the archives of musician David Tudor, artist Allan Kaprow, and collector Jean Brown. "Artists have always sought novel and innovative means to express their ideas, particularly in ways that connect with the culture around them," said Thomas Crow, director of the Research Institute from 2000 to 2007. "Video art has expanded since its beginnings in the 1960s to become the dominant art form of our time. We want to make sure this legacy is preserved."

Preservation efforts for these films and videos include cleaning and producing viewable copies of each work, storage in a temperature-controlled environment, and creating a master list of all items. Another conservation challenge is that artists may have used 8-millimeter, Super-8, or 16-millimeter film stock or made videos in beta, PAL, or another format. Conservators at the Research Institute preserve such works and transfer them to more-stable media. Additionally, because scholars need the right equipment, such as projectors and recorders, to view these works, the Institute has acquired an impressive array of vintage audiovisual devices in order to play them.

Analog archival masters and digital copy masters are generated in a reformatting lab (above).

Clockwise from top left: Video stills from Eleanor Antin, *Caught in the Act*, 1973; Nancy Buchanan, *Tech-Knowledge*, 1984; Patti Podesta, *Stepping*, 1980; and Tony Labat, *Solo Flight*, 1977.

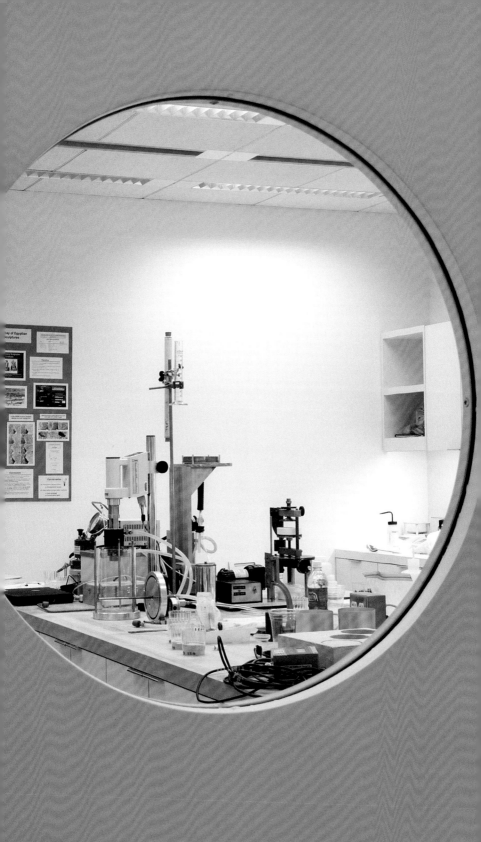

6 The Getty Conservation Institute

PRESERVING THE WORLD'S CULTURAL heritage, not only works of art but also buildings, monuments, archaeological sites, and other artifacts, is the mission of the Getty Conservation Institute. The Institute does not focus on the treatment of individual works per se; rather, it seeks to have a broader impact by conducting scientific research, training professionals in new methods and technologies, and making valuable information about conservation available worldwide to those who need it. The Conservation Institute often participates in collaborative undertakings to treat objects and sites around the world and has conducted field projects in Asia, Africa, North and South America, and Europe.

The Conservation Institute occupies most of the Getty Center's East Building, next to the Museum, on the city side of the campus. There its international team of scientists, conservators, archaeologists, and others conducts research in laboratories, develops and coordinates field and education projects, and disseminates critical information through publications, online databases, lectures and conferences, and a conservation information center. The Institute also maintains facilities at the Getty Villa.

The Conservation Institute formally began operation in 1985. Its first director, Luis Monreal, had advocated, in a meeting with Trust leaders two years prior, that the Institute devote its resources not only to the conservation of objects and collections but also to immovable cultural property, such as archaeological sites and monuments, particularly in countries rich in heritage but lacking the technical or financial resources to conserve it. The Trust ultimately embraced this direction, in what Harold Williams, then president and chief executive officer, later called a "transforming moment" for the Institute.

Since then, the Institute has embarked upon and helped to sustain a number of ambitious projects, including the conservation of the thirty-two-hundred-year-old wall paintings in the tomb of Queen Nefertari, Egypt; the ancient Buddhist grotto sites at Mogao and Yungang, China; and the oldest extant bas-reliefs from the Royal Palaces of Abomey, Benin. Other work has included such diverse projects as Conservation of Mosaics in Situ, Contemporary Art Research: Modern Paints, the Earthen Architecture Initiative, and Research on the Conservation of Photographs.

A view into a laboratory at the Conservation Institute, whose scientific department has about twenty-five scientists and support personnel. Expertise includes biology, chemistry, geology, materials science, physics, and engineering.

RESEARCH

Conservation science brings together research in various scientific disciplines in order to understand many of the causes for the deterioration of the objects, art, architecture, archaeological sites, and monuments that make up the world's cultural heritage. Scientists at the Conservation Institute work to develop approaches that can slow the decay of materials and prevent further damage. In association with conservators, the scientists design conservation solutions and evaluate treatment performance.

By adapting instruments and technologies originally developed in such realms as medicine and aerospace, staff scientists are able to analyze both organic and inorganic materials. The research laboratories are equipped with an array of sophisticated instruments to help scientists determine, first of all, what objects are made of, as well as when, how, and why they were made. Additional investigations explore possible causes of deterioration and ways to prevent or reduce them.

The Institute has also conducted extensive research into the properties of "binding media"—the substances that bind pigments together in paints and dyes. Many, such as linseed oil and egg tempera, have historically been derived from organic materials. Advanced methods such as gas chromatography-mass spectrometry, a powerful analytical tool widely used in biomedical work and environmental studies, allow scientists to identify proteins and other components of organic materials, discoveries that can lead to safer and more-effective conservation approaches. The Institute has also begun to focus on the synthetics, such as acrylic, used in many modern paints.

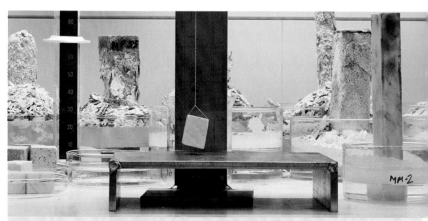

Common mortars, plasters, and stuccos, samples of which are seen in the photo above, are susceptible to deterioration from salt, which can also contribute to the corrosion of bronze and other metals. Because there are many kinds of salt, which can be found in everything from seawater and various soils to air pollutants, they present complex conservation problems for archaeological sites, historic buildings, outdoor monuments, and wall paintings. Using advanced technologies, such as time-lapse video microscopy and environmental scanning microscopy, Institute scientists can study salt crystallization and dissolution.

SPECIAL EQUIPMENT

Conservation Institute scientists employ sophisticated technologies and instruments. A scanning electron microscope in the laboratories uses a beam of electrons to magnify objects one hundred thousand times or more and produce detailed three-dimensional images. This equipment has enabled staff scientists to analyze weathered stone, bronze, and glass surfaces; determine the composition of ancient silver and gold objects; and identify rock art pigments.

X-RAY TECHNOLOGY

By partnering with the University of Bologna, Italy, which has expertise in the field of computerized axial tomography— CT scans—scientists at the Conservation Institute were able to adapt its current X-ray equipment to scan bronze sculptures in order to analyze and record their structural makeup.

AGING

The laboratories at the Conservation Institute include an Accelerated Aging facility, which can simulate the effects aging poses to various materials and surfaces.

Accelerated Aging
C215

No food or beverages

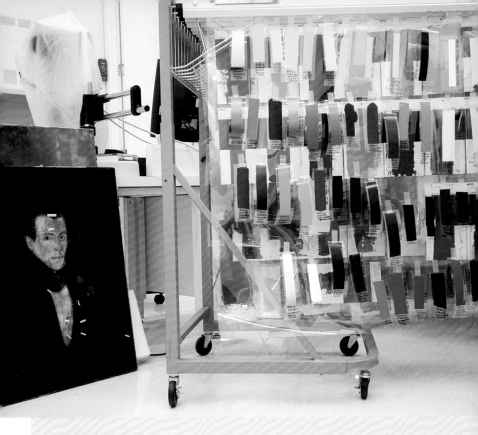

MODERN PAINTS

Painters once relied on a limited sup-
ply of materials. Pigments came from
mineral deposits or were extracted from
plants, insects, and animals; they were
mixed in such media as waxes, plant
gums, egg, milk, animal hides, vegetable
oils, and plant resins. Artists today may
turn to a variety of commercial paint
media—such as acrylics, nitrocellulose,
and alkyds—as well as a profusion of
synthetic pigments. The proliferation of
new materials has created correspond-
ing conservation challenges. Conserva-
tors have almost no information on
any of these products in terms of how
to identify them or how they might
alter with age or be affected by conser-
vation treatments.

To help answer essential questions
about modern paints, the Conserva-
tion Institute is working with Tate in
London and the National Gallery of
Art in Washington, D.C. This long-term
project's initial focus is on three main
areas: improved methods for chemi-
cal analysis, a better understanding
of the physical properties and surface
characteristics of modern paints, and
assessment of the effects of cleaning
treatments.

Each organization is bringing its
own particular area of expertise and
specialized equipment to bear on a
different aspect of research. The com-
bined results will enable conservators
to utilize appropriate cleaning methods
and techniques for modern paints and
will increase their understanding of the
problems that may develop over time
as a result of the additives used in some
commercial paints.

EDUCATION AND INFORMATION

The UCLA/Getty Master's Program on the Conservation of Ethnographic and Archaeological Materials, a three-year program that includes classes and lab work at the University of California, Los Angeles, and the Getty Villa, is the only graduate-level academic conservation program on the West Coast and the only U.S. program to focus solely on ethnographic and archaeological materials.

The Conservation Institute's Information Center provides expertise and support for the work of conservation professionals worldwide, offering customized research services, reference assistance, access to conservation literature, and visual resources. It manages a collection of approximately forty-five thousand volumes, including almost eight hundred current serial subscriptions, available online in the Research Library's catalog. The Information Center also maintains a reading room and reference collection of approximately two thousand titles.

The Abstracts of International Conservation Literature, AATA Online, is a free online resource that includes more than one hundred thousand abstracts of articles from almost five hundred journals, with quarterly additions of both current and historical conservation literature.

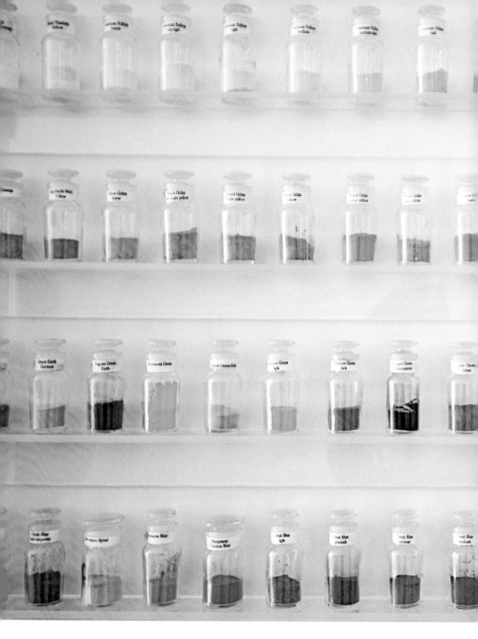

REFERENCE COLLECTION

The Conservation Institute's Reference Collection comprises more than nine thousand materials used in the analysis of art objects. Housed in an environmentally controlled room, the collection includes pigments and dyes, raw plant and mineral samples, wood and stone samples, natural and synthetic resins, varnishes, and examples of photographic chemicals and related materials. Scientists can search for information about the collection on an electronic database.

Above, a display of bottled pigments hangs on a wall outside the Institute's Organic Materials Analysis lab. As the world enters the digital age, it has become important to acquire obsolete photography supplies (left) in order to preserve analog photographs.

FIELD PROJECTS

To conserve even a fraction of the world's cultural heritage demands resources beyond those available to the Getty. By joining with other organizations, the Conservation Institute can take on a greater variety of projects around the globe. Such undertakings make it possible to apply the results of scientific research and to evaluate treatments. Most important, they provide learning opportunities for local professionals.

Projects have involved archaeological sites and historic buildings, from European cathedrals and Mediterranean mosaics to ancient Egyptian tombs, Mayan cities in Mexico and Central America, and thousand-year-old Buddhist caves along the Silk Road in China. Problems can include not only exposure to destructive natural forces but also looting and vandalism. Even tourism can create unexpected threats. An overall preservation strategy and master plan for a site requires diverse expertise. Comprehensive site management has been a major emphasis of the Institute's work, as has conservation for archaeologists.

The Institute has also undertaken research and field projects related to specific issues, such as adobe preservation, site preservation and reburial, and conservation of properties in humid, tropical environments. The tradition of building with earth, for instance, is evidenced the world over, but many significant sites are threatened. The Conservation Institute has collaborated with international partners to address such problems as the composition of mud bricks and to develop strategies to minimize damage to adobe structures from earthquakes and the elements.

Mosaic pavements constitute a shared inheritance from the Roman world throughout the Mediterranean region, but many are at risk. The Institute started the Mosaics in Situ project to enhance the conservation and management of these treasures.

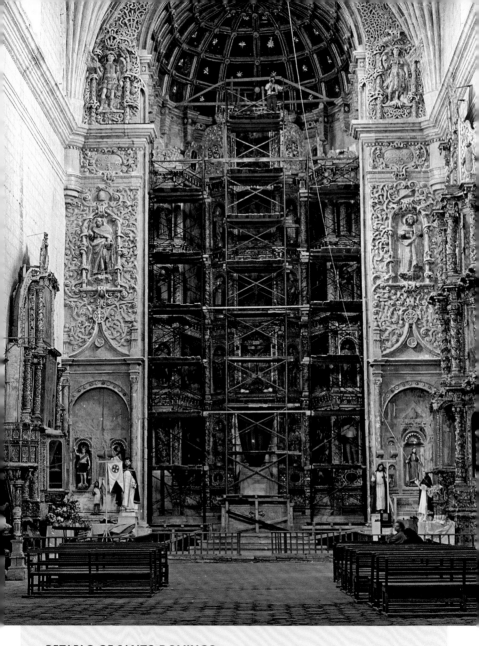

RETABLO OF SANTO DOMINGO

Built in the late sixteenth century, the main retablo of the Church of Santo Domingo in Yanhuitlán, Mexico, is constructed of gilded and painted wood and contains a number of sculptures and panel paintings. Nearly sixty-five feet high, it has sustained serious earthquake-related damage over the years. The Conservation Institute has collaborated with local and national Mexican organizations in documenting and providing a structural analysis of the altarpiece. The project included the involvement of Yanhuitlán community members who will be responsible for the long-term maintenance and security of all the retablos in the church.

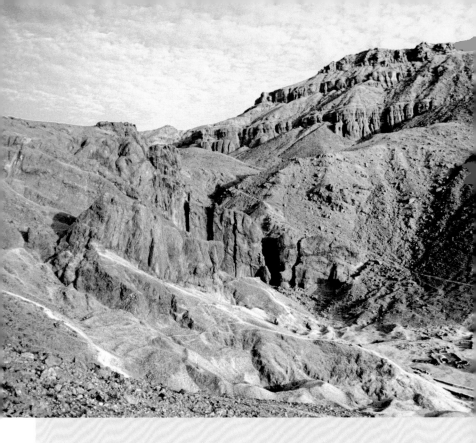

EGYPT: TOMB OF NEFERTARI, VALLEY OF THE QUEENS, AND CAIRO

The Conservation Institute's first field project focused on the thirty-two-hundred-year-old tomb of Queen Nefertari in the Valley of the Queens, on the west bank of the Nile near Luxor, Egypt. In collaboration with the Egyptian Antiquities Organization, a multidisciplinary, international group of experts conducted an intensive six-year campaign—beginning in 1986—which included condition assessment, analysis, emergency treatment, and conservation of the extraordinary wall paintings in the tomb. Training for conservators from Egypt and other countries was part of the project.

Today, the Conservation Institute is collaborating with Egypt's Supreme Council of Antiquities on the conservation and management of the Valley of the Queens. The program will involve the assessment of some eighty ancient tombs. Among the threats to the site are both natural forces (particularly flooding) and tourism. An important part of the project will include training for Egyptian professionals.

Other collaborative work with Egyptian authorities has included an environmental monitoring study of the Great Sphinx at the Giza Plateau outside Cairo and preparatory work for the conservation of the tomb of King Tutankhamen.

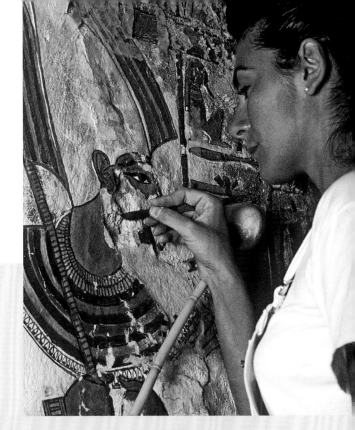

The Valley of the Queens in Egypt (left) was the site of the Conservation Institute's work on the tomb of Nefertari (above). The goal of the treatment was to stabilize the wall paintings, which over the centuries had been pushed out from the wall by salt deposits. Other projects in Egypt have included an environmental monitoring study of the Great Sphinx at the Giza Plateau (below).

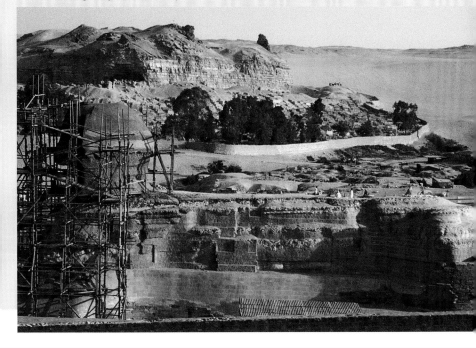

ST. VITUS CATHEDRAL IN PRAGUE

The Conservation Institute and the Office of the President of the Czech Republic collaborated on the conservation of *The Last Judgment* mosaic on St. Vitus Cathedral in Prague from 1992 to 2003. Located on the south facade of the building, the mosaic encompasses 84 square meters (904 square feet). It was completed in 1371 at the request of Charles IV, king of Bohemia and Holy Roman Emperor, who, during his reign, made Prague the empire's center of power, religion, and knowledge. Thirty-one shades of colored glass, plus gilded tesserae, can be found in the approximately one million glass pieces that compose the mosaic. Originally, the entire background of the work was gilded.

Despite attempts to restore the mosaic to its original appearance— the first as early as the fifteenth century—the corrosion continued into the twentieth century without a long-term solution. The problem was the composition of the mosaic's glass. The glassmakers used potash (potassium carbonate) extracted from the ash of burned wood in preparing the glass. When exposed to water, the potassium in the mosaic's glass leached out, interacting with air pollutants and resulting in the corrosion layer.

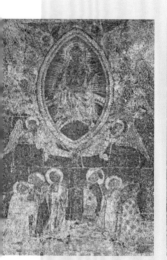
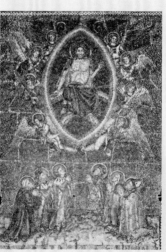
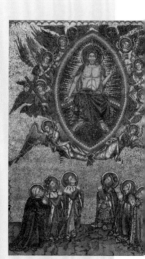

BEFORE TREATMENT AFTER CLEANING AFTER REGILDING

For most of its existence, *The Last Judgment* mosaic on St. Vitus Cathedral in Prague has had its brilliant colors rendered invisible by a layer of corrosion (left) that has formed after each cleaning. In consultation with leading Czech art historians and conservators, the Conservation Institute and its partners from the Department of Material Science and Engineering at UCLA developed a system of coatings to protect the surface after cleaning (center) and prevent further corrosion. Other measures included regilding (right) and establishing a regular monitoring and maintenance plan.

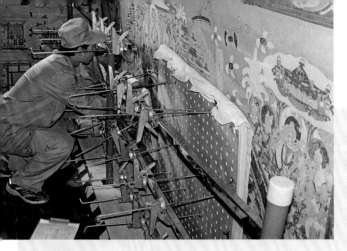

Chinese members of the project team work to conserve a wall painting in Cave 85—one of some 490 remaining temples at the Mogao grottoes.

CHINA: MOGAO GROTTOES

A major field project of the Conservation Institute involved the ancient Buddhist sites at the Mogao grottoes in the Gobi Desert in northwest China.

The ancient caravan routes linking China with the West, known in modern times as the Silk Road, once stretched 7,500 kilometers (4,660 miles) across the vast deserts of Central Asia. At the beginning of the first millennium, Buddhism traveled east from India along the trade routes and took root in China. In Dunhuang, an oasis town and gateway to China, Buddhist monks dug hundreds of temples into a cliff face—the earliest in 366, the last around 1300. Nearly five hundred of these grotto temples remain, and lining their walls are paintings on

clay plaster depicting legends, portraits, sutras, customs, costumes, and the arts. Some two thousand painted clay figures are also found within the grottoes.

Mogao was abandoned for centuries, and windblown sands smothered the grottoes, while decay overtook the wooden temple facades built on the cliff face. Working with the Dunhuang Academy at the Mogao grottoes, Conservation Institute activities included installing fences to reduce the effects of the windblown sand, monitoring the environment, training to check the color stability of the wall paintings' pigments, and surveying the structural stability of the cliff face.

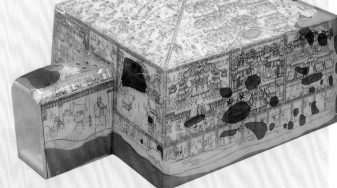

This three-dimensional model of a cave grotto records an analysis of water damage (in red).

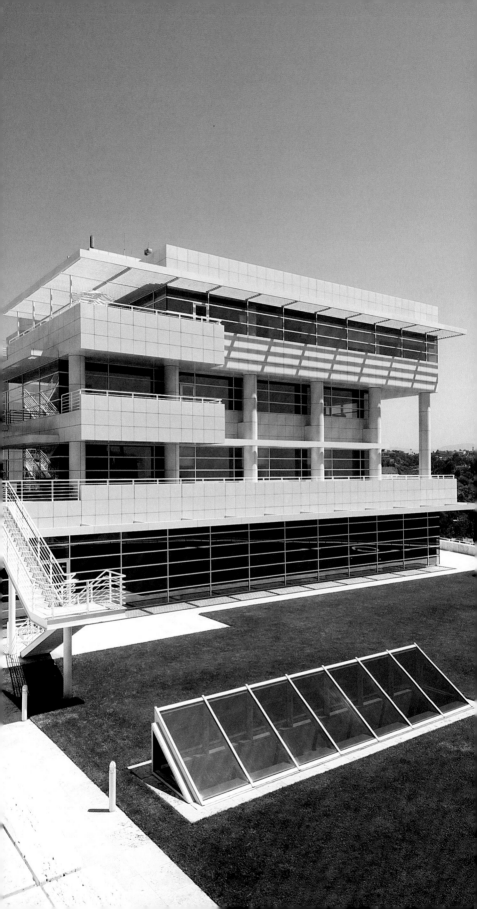

7 The Getty Foundation

AS THE PHILANTHROPIC DIVISION OF the J. Paul Getty Trust, the Getty Foundation (known until 2004 as the Getty Grant Program) provides grants to increase the understanding and preservation of the visual arts. The Foundation, established in 1984, funds both individuals and organizations—including museums, archives, universities, and other cultural entities—working in the visual arts around the world. Their contributions help strengthen the practice of art history and conservation, often focusing on creating access to important collections and knowledge. Other projects help nurture the development of current and future leaders in the visual arts. The results of all these efforts ultimately benefit both professional and general audiences.

Each summer the Foundation provides grants for more than 150 Multicultural Undergraduate Interns, who gain experience working at Los Angeles–area museums and visual arts organizations. Recipients from 2006 are shown here on the Museum steps.

The breadth of the Foundation's funding in the visual arts is intended to complement and further the work of the J. Paul Getty Museum, Getty Research Institute, and Getty Conservation Institute. Foundation projects encompass the visual arts in all their dimensions and from all time periods—from Mayan murals to medieval illuminated manuscripts to modern architecture. The Foundation's funding is also geographically broad, spanning more than 175 countries and seven continents.

HOW ARE GRANTS AWARDED? Each year, the Foundation receives many more inquiries and applications than it can support. With expertise in art history, conservation, scholarly access, and leadership training, the Foundation's staff evaluates proposed projects and makes final grant decisions. Applications are also submitted for peer review by experts in art history, conservation, and related fields.

Individuals and organizations interested in applying for Foundation support are encouraged to visit www.getty.edu/grants for specific information about current grant categories, deadlines, application instructions, and past grant awards.

A view of the southern face of the East Building, home to the Getty Foundation.

129

RESEARCH GRANTS

Research grants are awarded for projects that strengthen the practice of art history, with an emphasis on strategies that encourage academic exchange and interdisciplinary research. Projects that make important museum and archival collections accessible are also a priority. Many research grants support activities—such as cataloguing or conservation research—that are not visible to the public but provide the basis for new scholarly work and innovative projects.

In recent years, research grants have told the story of Ferdinand Columbus—the son of Christopher Columbus—who collected and organized a remarkable collection of sixteenth-century prints, which are housed today at the British Museum. Closer to home, a series of research grants is helping museums, universities, and art schools in Los Angeles piece together the history of avant-garde art in Los Angeles in the decades after World War II.

THE ARTS IN LATIN AMERICA

A research grant from the Getty brought together an international team of scholars to plan the critically acclaimed exhibition *The Arts in Latin America, 1492–1820.* The show, which opened at the Philadelphia Museum of Art in 2006 and traveled in 2007 to Mexico City and Los Angeles, looks beyond national boundaries created in the early nineteenth century in order to explore artistic interchange throughout colonial Latin America. While on view at the Los Angeles County Museum of Art, the exhibition was accompanied by a host of public programs—supported by another Getty grant—including a film festival, symposia, lectures, concerts, and family programs, all designed to engage Los Angeles audiences.

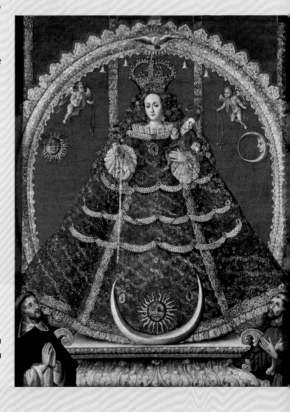

Luis Niño, *The Virgin of the Rosary with Saint Dominic and Saint Francis of Assisi,* ca. 1737. Oil on canvas. Museo de la Casa Nacional de Moneda, Fundación Cultural BCB, Potosí, Bolivia.

CONSERVATION GRANTS

Ensuring that works of art are preserved for future generations is the goal of the Foundation's conservation grants, which support the preservation of museum objects as well as historic buildings and sites. One of the hallmarks of these grants is their emphasis on advancing conservation practice through interdisciplinary research and training.

At the Victoria and Albert Museum, London, an innovative project is bringing together Japanese and English conservators to preserve the Mazarin Chest, one of the finest surviving examples of seventeenth-century Japanese export lacquer. In Egypt, at the foot of Mount Sinai, Getty grants have helped conserve the magnificent sixth-century mosaics in the central apse and the Burning Bush Chapel of the Holy Monastery of Saint Catherine. Like other Getty-supported conservation efforts, both projects integrated new research with established conservation standards in order to preserve important works.

UNVEILING OF THE SAN SILVESTRO CHAPEL AT THE SCALA SANTA

The results of Getty-funded conservation planning and treatment projects at the Pontificio Santuario Scala Santa in Rome were unveiled in the summer of 2007. Visited by more than two million people a year, the Scala Santa contains an ancient marble staircase believed to be the steps Christ ascended to receive his judgment by Pontius Pilate. The stairs lead to the San Silvestro Chapel, where the extensive frescoes decorating the walls and ceiling had become so darkened that there was little hope of their survival. Following extensive research and planning, as well as a painstaking conservation process, the project team of conservators and art historians revealed the original paintings in astonishing clarity and color. To share the results of the project, the Foundation is also now supporting the publication of a book about the work.

Fresco of *Pope Sixtus V as Saint Sylvester*, ca. 1589, in the San Silvestro Chapel, after conservation, 2006.

PROFESSIONAL DEVELOPMENT

The Foundation nurtures and equips current and future leaders in the visual arts through grant funding as well as through the programs of the Getty Leadership Institute, which provides intensive training for senior museum staff and board members. Grant funds support the professional development of museum curators, emerging scholars, and young people exploring careers in the visual arts through internships and a variety of research fellowships. Other grants have supported summer institutes for scholars in the United States and abroad and training opportunities for conservators from developing countries.

Undergraduate intern handling a fragile political poster during his internship at the Center for the Study of Political Graphics in Los Angeles.

SPECIAL INITIATIVES

Because of the flexibility of its initiatives, the Foundation occasionally takes on special local, national, and global projects that are in line with the Getty's mission but that require more-immediate consideration and assistance.

LOS ANGELES Complementing its international scope, the Getty Foundation maintains a special relationship with its home city of Los Angeles through a variety of programs designed to support area organizations. The Getty's Multicultural Undergraduate Internship program, for example, has funded, since 1992, summer internships for more than two thousand college students at 140 museums and visual arts organizations across Los Angeles. In 1999, the Los Angeles Arts Commission joined the Getty by launching a parallel internship program in the literary and performing arts, forming an ongoing public-private partnership.

On the Record: Art in Los Angeles, 1945–1980, a special initiative undertaken by the Foundation in collaboration with the Getty Research Institute, provides grants to make accessible documentary collections that tell the story of avant-garde art in Southern California in the post–World War II decades. Other funding initiatives have helped to conserve historic buildings and landmarks across Los Angeles and to provide online access to more than one million works of art in local collections.

FUND FOR NEW ORLEANS Launched in the wake of Hurricane Katrina's devastation, the Getty Fund for New Orleans is helping revitalize the city's cultural institutions through grants designed to help organizations assess damage to their collections and adapt to the city's changed arts environment. Fourteen grants totaling nearly two million dollars have been awarded to cultural institutions of all sizes, from the city's landmark museums in the French Quarter to historic house museums and small community arts organizations.

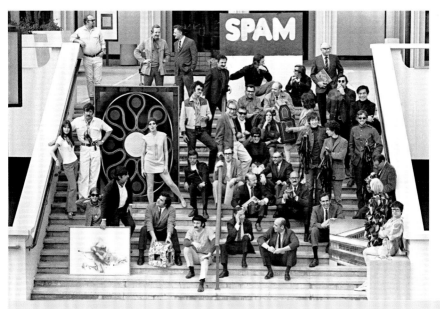

This photograph by Julian Wasser of Los Angeles art figures on the steps of the Los Angeles County Museum of Art in 1968 is one of many documents to be researched and made accessible through the Foundation's On the Record initiative.

Classical Revival–style mansion at Longue Vue House and Gardens during post–Hurricane Katrina moisture mitigation, New Orleans, 2005.

8 The Getty Outside and In

VISITORS TO THE GETTY CENTER AND the Getty Villa are usually there to see the buildings and the masterpieces of art contained within them. It is possible, though (but not necessarily encouraged), for visitors not to enter a single gallery and still be richly rewarded. At the Center, the Central Garden, described by its creator, the artist Robert Irwin, as "a sculpture in the form of a garden aspiring to be art," offers a feast for the senses. There are also two sculpture gardens with twentieth-century pieces by Henry Moore, Mark di Suvero, and Alexander Calder, among others. Commissioned works by such contemporary artists as Martin Puryear, John Baldessari, Ed Ruscha, and Alexis Smith can be found both inside and outside buildings at the Center.

Meanwhile, the Getty Villa features gardens and fountains, where visitors can escape from their cares into the beauty of nature. Opposite the Villa's Fleischman Theater, the East Garden contains a replica of a fountain from Pompeii, decorated with mosaics of stone and glass tesserae as well as seashells. Visitors to the Outer Peristyle can stroll the shaded colonnades, enjoying the open air and ever-changing views of sky, plants, fountains, and statuary. The Outer Peristyle's trompe l'oeil wall paintings, created by the artist Garth Benton, were inspired by examples excavated in the homes of wealthy Romans.

Both sites contain many areas, both inside and out, that are not seen by the general public. At the Villa, Getty's original Ranch House now contains modern offices, a library, and meeting and study rooms. Below the Museum galleries and Entrance Hall at the Center is a veritable hive of activities. This minicity includes curatorial offices, fabrication workshops, design and photography studios, an internal post office, conservation and computer labs, art storage rooms, security headquarters, and more. Outside on the Getty Center grounds are a helicopter pad (for emergencies), a million-gallon firefighting water reservoir, and a plant nursery. In 2005 the Center became the first facility in the nation to achieve LEED-EB (Leadership in Energy and Environmental Design–Existing Buildings category) certification from the U.S. Green Building Council—a sign of the Trust's commitment to the environment and to managing its resources efficiently.

The sycamore-lined stream in the Getty Center's Central Garden, designed by the artist Robert Irwin. The rocks in the streambed are green chert from the Gold Country in northeastern California.

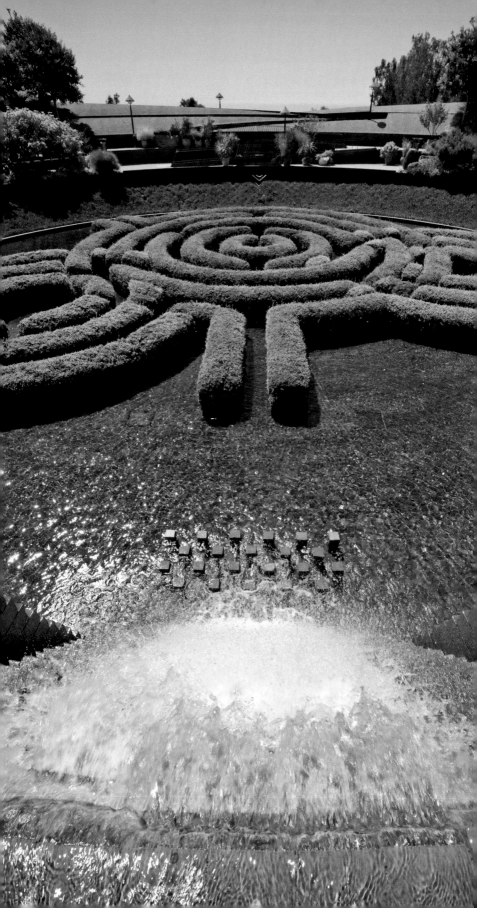

GARDENS AT THE GETTY CENTER

THE CENTRAL GARDEN Designed by the artist Robert Irwin, the Central Garden lies at the heart of the Getty Center. The garden's 134,000-square-foot design reestablishes the natural ravine between the Museum and the Research Institute, with an inviting, tree-lined walkway that leads visitors down to a plaza and an azalea maze that seems to float. Around the pool is a series of specialty gardens, each with a variety of plants.

Robert Irwin in the Central Garden.

A native of Southern California, Irwin started out as a painter interested in color and perception. He first came to prominence in the late 1960s as a proponent of the California Light and Space movement. During this period, he created a series of subtly painted, convex aluminum discs that, strategically illuminated by spotlights on the ceiling and floor, seemed to float in space. Many of the issues that first interested him in the 1960s persist in his design of the Getty's Central Garden.

The garden walkway traverses a stream that descends to a plaza with bougainvillea arbors (below). The stream continues through the plaza, passes below a steel bridge, and seems to end in a cascade of water over a stone waterfall into a pool with an azalea maze (left). What most people don't know, however, is that for drainage reasons, the upper watercourse and the waterfall are actually two separate systems. The stream water runs its course, drops down into a catch under the bridge, and is then sent back up via an underground channel to the top of the garden. On a different track, the water for the waterfall is pumped in just before it plunges over the wall, then mingles around the azalea planters before being piped back up to the bridge.

In his design, Irwin integrated the slope of the ravine as an active part of the garden, giving it enough scale to play a strong role and incorporating a walkway lined with Yarwood sycamores that crosses a small stream edged with a variety of grasses. The sycamores are pruned monthly during the summer growing season to maintain the experience of dappled light as the visitor walks through the upper garden. The visitor passes over the stream five times during the descent into the garden, and each time the sound of the water varies due to Irwin's purposeful placement of boulders to affect the speed and cascade of the flow.

Irwin selected his materials for their visual qualities, such as pattern, color, texture, and capacity to reflect light. In Irwin's garden, these geometries are compounded by repetition until they are perceived as patterns, and, in turn, patterns are repeated until they are experienced as rich layers of textures.

A teak bench in the upper garden offers a quiet, shady place of reflection (left). The plants situated along the Central Garden's zigzag walkway were broken by Irwin into four groups, each with expressly designed qualities; those at the bottom of the walkway (above) are the most vibrant, verdant, and richly textured.

SEASONAL CHANGES

A change in plantings in the specialty gardens around the azalea pool is one way the seasons are marked in the Central Garden. Poppies (top left) in the spring (February to June) are followed by a profusion of dahlias in many shades of yellow and red (middle left) for the summer planting (June to November). (There is no planting rotation for fall.) The "red sticks" of wintering dogwood (bottom left) are the dramatic addition for the winter season (November through February). A freak storm (below) in January 2007 even brought snow to the Central Garden. The sycamores along the upper garden drop their leaves in the fall (right), which creates a very different experience than the dappled light of the summer garden.

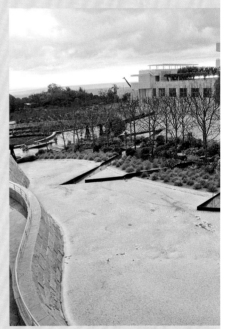

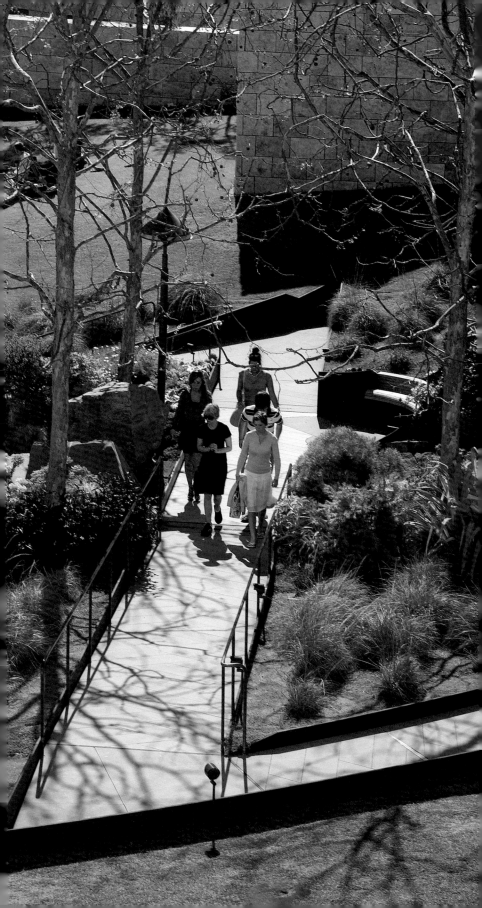

OTHER GARDEN SPACES The other gardens around the Getty Center not only balance the natural and the man-made but also define the spaces between buildings. The landscape architecture firm Olin Partnership, led by founding partner Laurie Olin, contributed to the Center site plan an overall design that combined formal and informal courtyards planted with trees, shrubs, and flowering plants. The landscaping and gardens tie untouched outlying chaparral both to the ordered plantings surrounding the Center and to the carefully structured gardens inside the campus proper. Native, drought-tolerant materials (cactus and succulents) and transplants from other locales (Italian stone pines and tropical palms) work sometimes in harmony with, and sometimes in counterpoint to, the architecture. Cool colors on the shady northern slopes grow warmer as the site opens to the sun and then deepen into a desert palette at the southernmost promontory.

The South Promontory's cactus garden (left), a re-creation of a desert landscape, recalls the city's preurban state. The palm garden (right), tucked between the East and North Buildings, gives passersby a rare treat of seeing trees from overhead. This sunken garden also allows sunlight to fill the below-grade offices through windows in the buildings' perimeter walls.

Many gardeners use containers to hold their plants. At the Getty Center, container planting is taken to an extreme. Because there are offices and corridors below much of what visitors see, plants are not placed directly in the ground. Even this stand of four Italian stone pine trees (right) on the Arrival Plaza is situated in a large—and contained—planting bed.

GARDENS AT THE GETTY VILLA

The many garden spaces at the Getty Villa are meant to echo those found in Roman antiquity, a task made easier by the fact that the climate at the location is remarkably similar to that of the Bay of Naples. Gardens were an important part of life in the ancient Roman countryside: often house and garden were so closely integrated that it was difficult to tell where one ended and the other began. Even the most humble dwelling had a small walled-in space in which to grow herbs and greenery. Roman homeowners worked, played, ate, and relaxed in their gardens, which, like those at the Villa, caught cooling breezes and made the most of pleasant vistas. The varieties of plants and flowers in the Villa's gardens mirror those planted in ancient Greece and Italy.

OUTER PERISTYLE The Outer Peristyle is reached from the triclinium through two bronze doors and is one of the most dramatic spaces at the Villa. Eight stately Corinthian columns look out onto a grand expanse. Smaller Doric columns adorn the three other sides of the garden. It is adorned with hedge-lined pathways and circular stone benches. Plants favored by the ancient Romans, such as bay laurel, boxwood, myrtle, ivy, and oleander, are planted around a spectacular 220-foot-long reflecting pool.

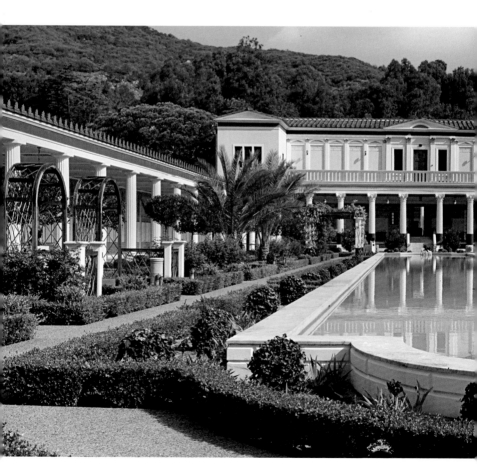

Helleborus argutifolius

Corsican Hellebore

The Herb Garden features numerous plants known in antiquity, such as Corsican hellebore (above), which was used for medicinal purposes. Among the florae in the Outer Peristyle (below) are lavender, thyme, bellflowers, irises, acanthus, grapevines, fan palms, date palms, and pomegranate trees.

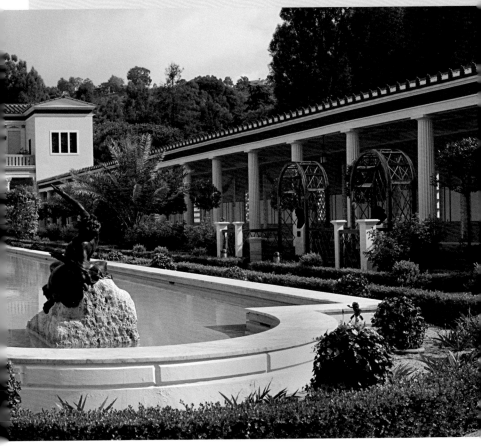

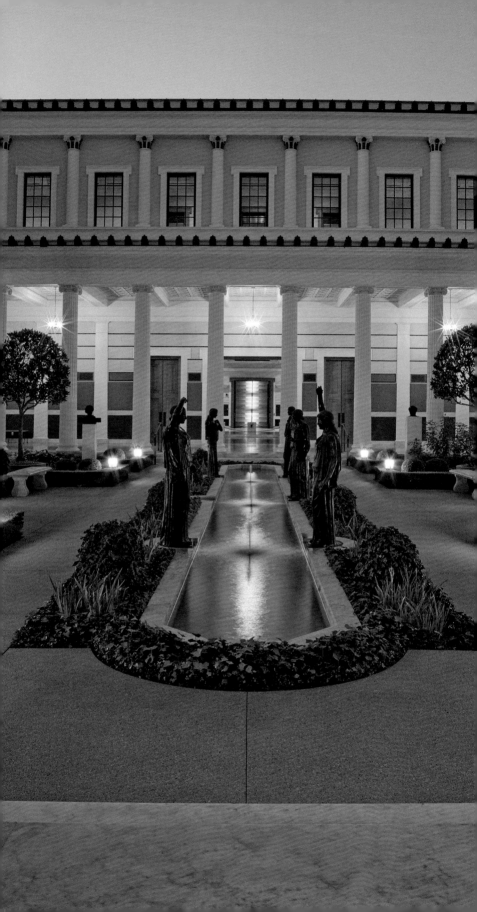

HERB GARDEN Most Roman residences had both a decorative garden and one for household use. The Herb Garden is a re-creation of a Roman kitchen garden and is planted with species known from the ancient Mediterranean—fruit trees, flowering shrubs, and herbs used in cooking and for medicine. It contains mint, dill, coriander, oregano, marjoram, chamomile, and several kinds of thyme. Fennel, radishes, and other vegetables are planted among the herbs. Fruit trees—apple, peach, pear, fig, and citrus—and grapevines abound. A typically Mediterranean olive grove stands on the terraces above the garden.

INNER PERISTYLE The garden in the Inner Peristyle features laurel, viburnum, and myrtle as well as rosemary hedges, lavender, and ruscus. It is surrounded by thirty-six Ionic columns, whose capitals were inspired by the curling leaves of the acanthus plant, examples of which can be found in the Inner Peristyle as well as the East Garden.

EAST GARDEN The East Garden offers one of the most tranquil spaces at the Villa. It features a replica of an ancient fountain from the House of the Large Fountain in Pompeii, decorated with stone and glass tesserae, shells, and theater masks. In the center of the garden is a circular basin with bronze civet-head spouts copied from those discovered in the atrium of the Villa dei Papiri.

The Inner Peristyle lit at night (left). The East Garden (above) contains both a circular fountain and a mosaic fountain (in the background).

OUTDOOR ART AT THE GETTY CENTER

THE FRAN AND RAY STARK SCULPTURE COLLECTION The twenty-eight twentieth-century sculptures that constitute the Fran and Ray Stark Sculpture Collection were generously donated in 2005 to the J. Paul Getty Trust by the Trustees of the Fran and Ray Stark Revocable Trust and are installed throughout the Getty Center in the city where the Starks made their home for more than sixty years. Many of the century's foremost sculptors are represented, including Alexander Calder, Alberto Giacometti, Barbara Hepworth, Ellsworth Kelly, Roy Lichtenstein, Aristide Maillol, Joan Miró, Henry Moore, and Isamu Noguchi. Integrated with the environment and architecture of the site, these works are an impressive addition to Richard Meier's celebrated design and a rich complement to the renowned collections of the J. Paul Getty Museum.

Richard Meier's elegant modernist architecture provides a context well suited to the display of the Fran and Ray Stark Collection of twentieth-century sculpture, including Giacomo Manzù's *Seated Cardinal* (above), Mark di Suvero's *Gandydancer's Dream* (top right), and Ellsworth Kelly's *Untitled* (bottom right).

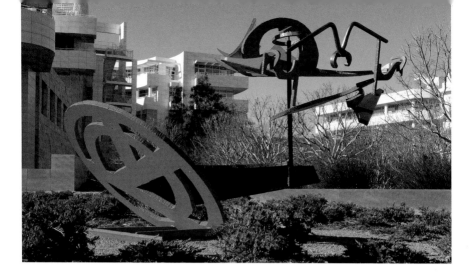

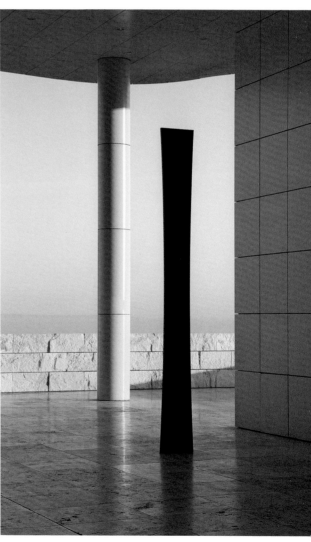

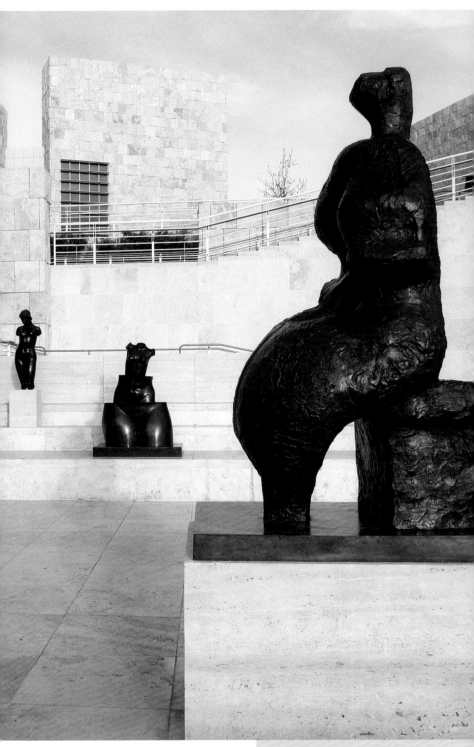

The Stark Sculpture Terrace features
(above, left to right) Aristide Maillol's
Torso of Dina, René Magritte's *Delusions
of Grandeur*, and Henry Moore's *Seated
Woman*, among other works.

THE STARK COLLECTION: BEHIND THE SCENES

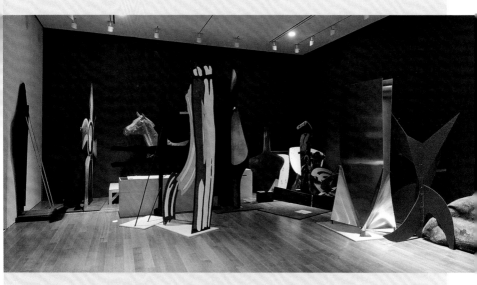

These life-size mock-ups (above) of the Stark sculptures, made by Getty exhibition design staff, were used to plan the placement of the real works. From a distance these "fakes"—made from plywood, foam core, and photo reproductions—turned out to be very convincing facsimiles. Visitors were surprised to see these stand-ins being dragged all over the Getty Center.

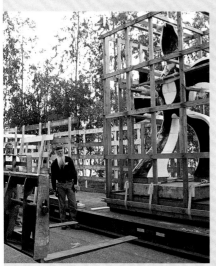

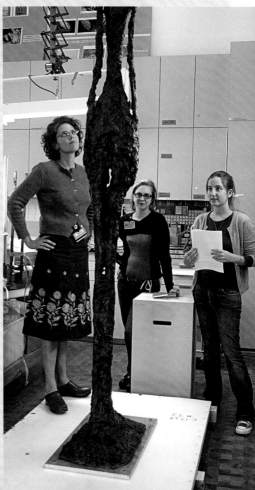

Once at the Center, sculptures such as Fernand Léger's *Walking Flower* (above) were first inspected and unloaded by preparators. The works—including Alberto Giacometti's *Standing Woman I* (right)— were then examined by Museum staff to record their condition and, if necessary, undergo any conservation treatments prior to their installation.

OUTDOOR ART AT THE GETTY VILLA

Outdoor sculptures, many based on those excavated from the Villa dei Papiri, are located in each of the four primary gardens at the Getty Villa. A grouping of modern bronze reproductions in the Inner Peristyle depicts both men and women from antiquity, including a copy of Polykleitos's *Doryphoros* (Spear-bearer). In and around the large central pool and throughout the garden of the Outer Peristyle are bronze statues and busts, which, like those in the Inner Peristyle, were cast in Naples after sculptures found in the Villa dei Papiri. Two graceful deer flank the steps leading down into the garden from the Museum colonnade. Renderings of gods, heroes, rulers, poets, and athletes, in a variety of styles, are symmetrically placed throughout the garden. At the north end of the pool a beardless young satyr sleeps on a rock, while an older drunken satyr rests at the other end. At the far end of the garden is a seated figure of the messenger god Hermes.

In the East Garden, adorning the mosaic-and-shell niche fountain, are two marble theater masks, one depicting Herakles wearing his lionskin, the other portraying his cousin, Dionysos, the patron god of theater. The Herb Garden contains an amusing sculpture of a Silenos riding a bulging wineskin—a copy of a statuette from the Villa de Papiri—which forms a spout through which water runs into a large pool below.

Many of the wall paintings in the Outer Peristyle were inspired by those discovered in well-known ancient Roman homes. Throughout the Villa the artist Garth Benton—who, thirty years prior, had painted the original murals—

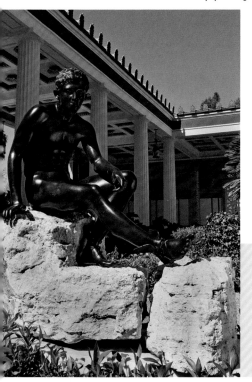

repainted and retouched the works, which deftly combine elements from numerous paintings in antiquity, so that, while his creations are true in spirit to those from long ago, none are mere copies. The walls of the north, east, and west porticoes of the Outer Peristyle are decorated with illusionistic paintings of a style fashionable in the first century B.C. and depict architectural details, animals, fruits, and flowers, all using colors that match paint specimens found in antiquity.

In the Villa's Outer Peristyle, a modern replica (left) of a bronze statue from the Villa dei Papiri portrays the messenger god Hermes (or Mercury, as the Romans called him). At right, a detail from one of the artist Garth Benton's frescoes in the Outer Peristyle mirrors the natural beauty of the Villa gardens.

CONTEMPORARY ART

While the Getty Museum primarily collects antiquities and pre-twentieth-century European art, the Getty Center also features contemporary works. Over the years, the Getty has commissioned artists such as Martin Puryear, Ed Ruscha, Bill Viola, Tim Hawkinson, Alexis Smith, and John Baldessari to produce pieces that are site-specific or respond to works in the Getty's collection. Puryear's distinctive *That Profile*, one of the first things visitors see as they exit the tram, dramatically plays against its surroundings, both natural and man-made. Hawkinson's massive *Überorgan* (see pages 84–85) made its West Coast debut in 2007 in the Museum Entrance Hall, where it amused and surprised visitors as much for its sheer size as for the deep, often jarring music that it made. The contemporary art programming is a reflection of the Getty's support of living artists and the local artistic community.

A plate from Alexis Smith's *Taste* installation in the Getty Center Restaurant.

A dramatic Los Angeles sunset seen against Martin Puryear's *That Profile*.

Ed Ruscha's painting *Picture Without Words* in its permanent home in the lobby of the Harold M. Williams Auditorium.

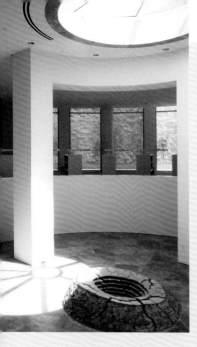

Works commissioned by the Getty have included Bill Viola's video *Emergence* (above left); Andy Goldsworthy's untitled temporary installation (above middle) in the Research Institute's lower level; John Baldessari's *Specimen (After Dürer)* (right); Nicole Cohen's *Please Be Seated* (below left), in which visitors sit in modern reproductions of eighteenth-century French chairs and are "transported" via video to a period room; and Tim Hawkinson's *Bat* (below), made from plastic RadioShack bags and twist ties.

DINING AND SHOPPING

Visitors to the Getty Center can enjoy meals at either the casual Cafe, the elegant Restaurant, or the outdoor Garden Terrace Cafe. The Cafe at the Getty Villa serves Mediterranean fare and has indoor and outdoor seating and views of the Museum and Fleischman Theater.

The Museum Store at the Center is filled with a wide variety of books, gifts, and educational toys relating to the collections and programs of the Getty. Smaller stores dot the Center site and offer products that reflect exhibitions and gallery themes. A children's shop caters to the many school groups that visit. The Museum Store at the Villa features publications on the ancient world as well as products inspired by the Museum's collection of antiquities.

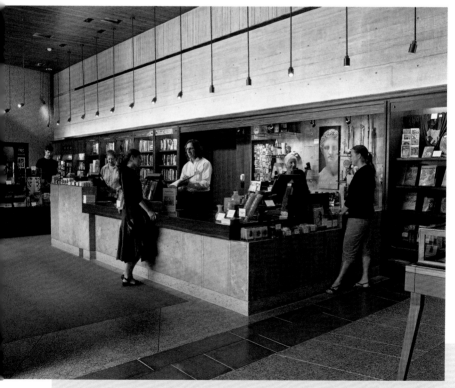

At the Museum Store at the Getty Villa (above) visitors can purchase books, prints, cards, gifts, and jewelry with an ancient twist. The Museum Store at the Getty Center (top) offers books covering the spectrum of art history. The Garden Terrace Cafe at the Getty Center (right) overlooks the Central Garden.

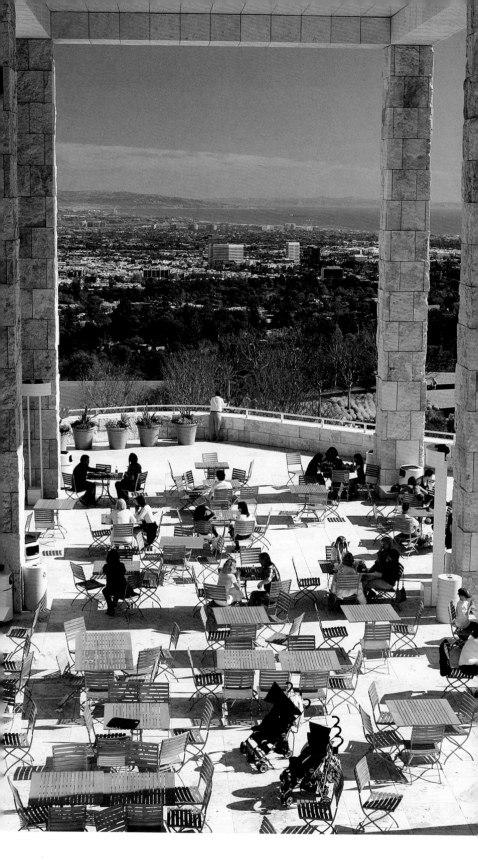

TUNNELS

More than half the space of the Getty Center is underground. The buildings are linked by a network of subterranean corridors used for a variety of purposes, including the moving of works of art, books, and scientific equipment. The placement of the water pipes within the corridors was part of the overall design, to keep them out of storage and office spaces.

WALL OF HANDS

The Wall of Hands was created on the occasion of the opening of the Getty Center. Staff members were invited to put their handprint into thirty-inch squares of wet plaster. Many individuals signed or personalized their imprint in some way.

TRAM CONTROL ROOM

The tram control room is located below the Museum. Inside is the brain that controls the wheels and cables that move the two unmanned trams up and down the hill.

EMPLOYEE ART SHOW

Held every other year, the employee art show, called "Getty Underground," is an opportunity for staff to share their artistic talents. The exhibition is mounted in one of the many underground tunnels.

BOILER ROOM

The Center's boiler room is located four floors underground in the Museum building. The boilers supply hot water for domestic purposes and to heat the buildings; and steam for humidification. At least one boiler is running twenty-four hours a day, 365 days a year.

GOATS AT THE GETTY CENTER

The Getty Center occupies only 24 acres of the 110-acre developed site. The remaining land has been left in its natural state or planted with consideration for erosion and fire control. Brush clearance is part of the landscape maintenance program, and most areas can be cleared by staff. There are canyon spaces, however, that are too difficult to reach safely. The solution has been to bring in a herd of 250 goats each spring for a period of two weeks to get in and take care of these areas, which account for approximately 12 acres.

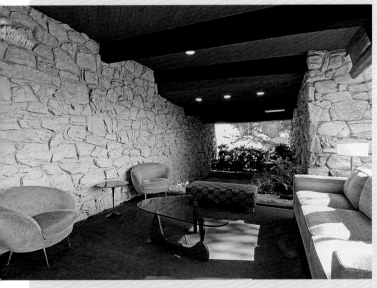

THE TRUSTEE HOUSE

When the Getty bought the land for the Center, this modern house on the property was part of the purchase. Originally built in 1965 by the architect Harry Gesner for the famed inventor J. R. Scantlin, the home features a 180-degree view of Los Angeles and a lap pool that leads from outside directly into the master bathroom. Richard Meier lived in the Scantlin House during the building of the Center. Now referred to as the Trustee House, it is used primarily for meetings.

NURSERY

Fresh plant stocks for the Getty's Central Garden and other gardens are kept at a nursery on-site. Seasonal plants are also stored here.

WILDLIFE

The Getty site is home to many forms of wildlife, such as deer, hawks, ravens, owls, and coyotes.

EMERGENCY HELIPAD

On September 24, 2007, a Los Angeles Fire Department helicopter landed on the Getty's helipad, near the North Building, on the occasion of a town hall meeting held at the Getty on fire safety and disaster response.

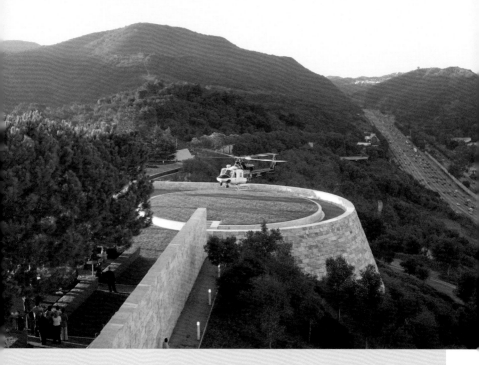

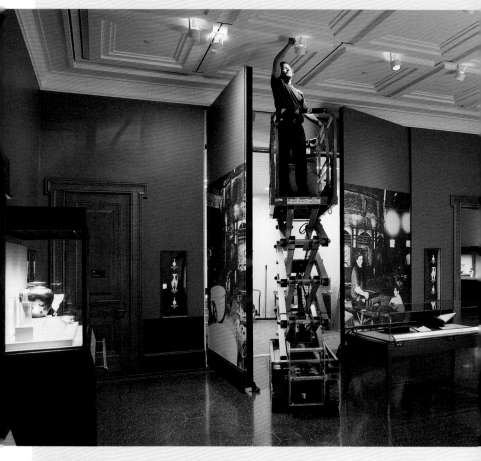

LARGE HIDDEN ELEVATOR

This elevator, hidden behind a gallery wall, is used to transport machinery, cases, and works of art to and from the Museum galleries.

FIREPLACES

This fireplace is the original one in the living room/salon of Getty's Ranch House. It has fluted pilasters with swags of grapes and capitals in the form of women's faces, which support a classical-order-entablature mantel.

MONKEY FOUNTAIN

This marble fountain, referred to informally as the "Monkey Fountain," is located in the courtyard outside the conservation labs, just south of the Ranch House. It is a replica of a fountain by Giovanni da Bologna (1524–1608) in the Boboli Gardens, Florence. A trio of monkeys adorns its base.

VIP ROOM

This meeting room, with dramatic Pompeiian red walls, is located on the first floor of the Museum.

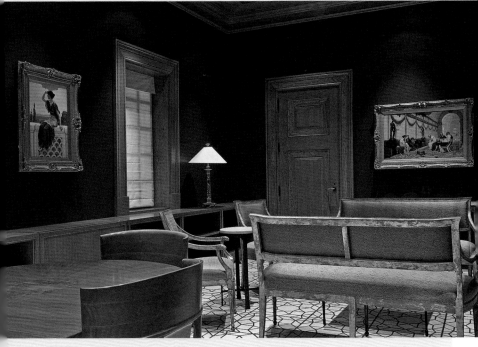

MEMORIAL GROVE

Established in the 1980s, the Memorial Grove was created to honor staff members who passed away as employees of the Trust. Their names are inscribed into rocks, which are placed beneath trees.

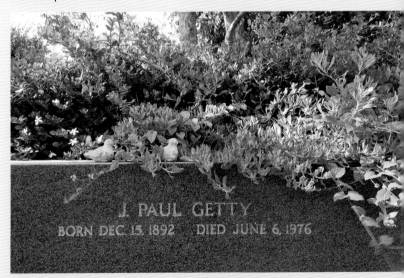

J. Paul Getty is buried at the Getty Villa—on a bluff overlooking the Pacific Ocean. Two of his sons, George and Timothy, are also laid to rest here.

REDWOOD GROVE

J. Paul Getty was especially fond of this grove of redwood trees, originally brought down from Oregon in the 1940s and located just south of the Museum.

BUNGALOWS

This bungalow (one of a pair) was home to John and Minnie Batch, who were hired as caretakers of the property by J. Paul Getty. The large painting depicts John, who also acted as Getty's bodyguard.

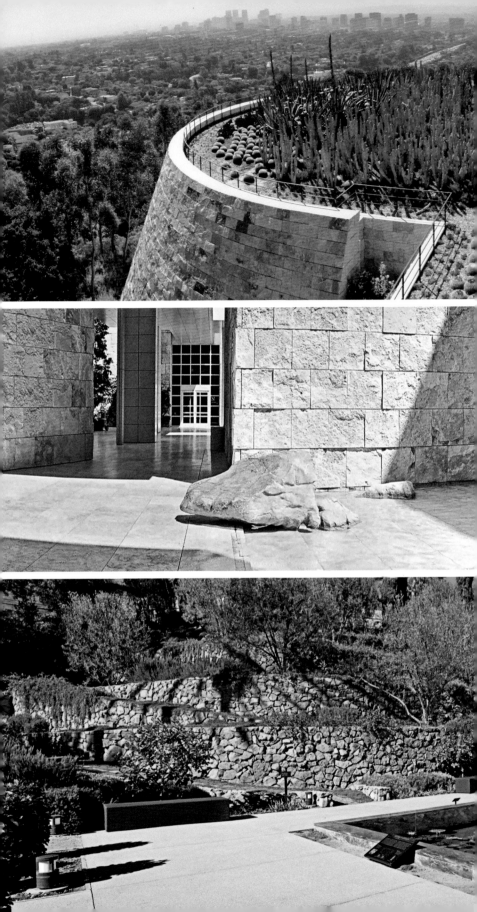

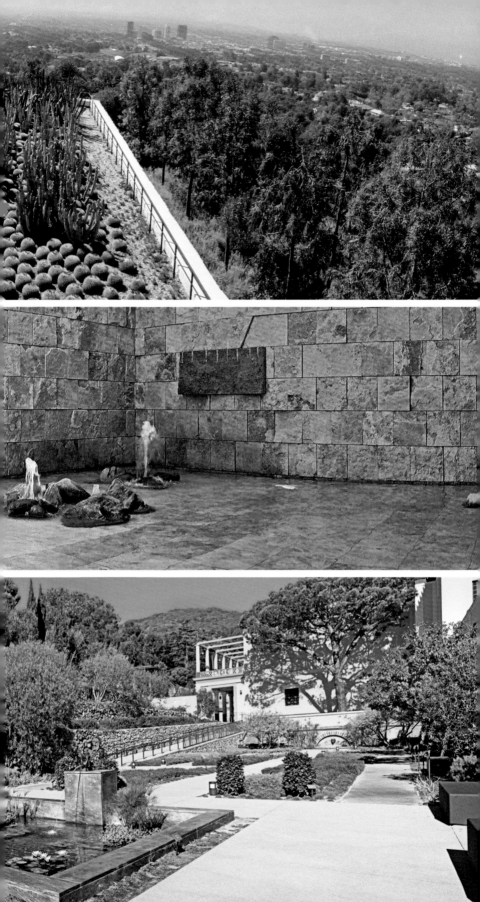

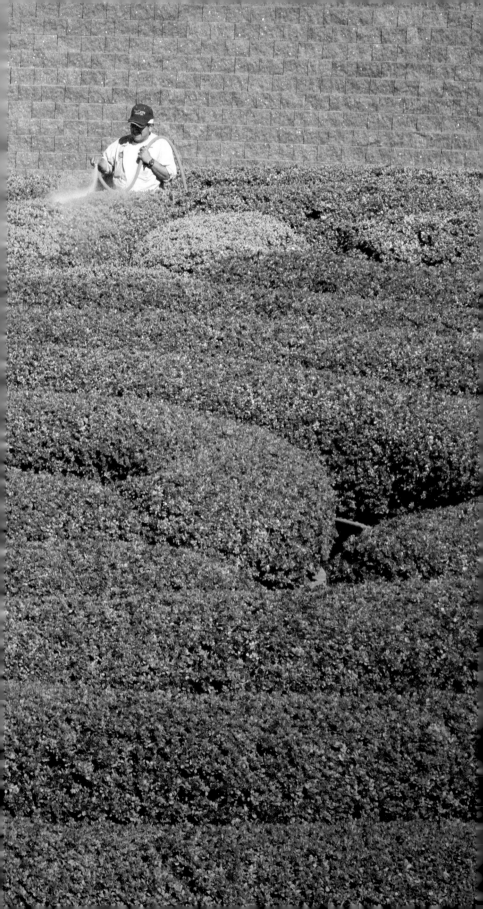

9 A Day at the Getty

FOR VISITORS, A DAY AT THE GETTY
Center or Villa is an escape from everyday worries and the stress of modern city life. One can take in priceless works of art, eat a great meal, relax in a verdant garden, and enjoy a stimulating performance. However, there are many other facets of the institution that the public does not see. To maintain and operate both sites requires many dedicated people and resources. The following sequence of pictures represents just some of the daily activities that take place at the Getty's two busy campuses. It is by no means comprehensive but aims to give readers a glimpse into life at the Getty.

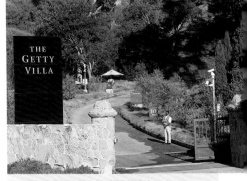

WELCOME TO THE VILLA
The Getty Villa plays host to about fifteen hundred visitors a day.

VISITOR SERVICES
The Museum's Visitor Services Department welcomes visitors to both sites, gives directions, and answers such questions as "Where's *Irises?*"

GROUNDS CREW
A gardener (left) waters the azalea maze in the Central Garden. There are four full-time gardeners dedicated to the Central Garden and thirty-two gardeners in all for the Getty Center. The Getty Villa has fourteen full-time gardeners.

SECURITY OFFICERS
The Getty Security team meets for its morning briefing.

UMBRELLA, ANYONE?
Umbrellas are provided to visitors as protection from the rain or, more often, the sun.

CALL CENTER
The Getty's call center fields hundreds of requests every day.

SUNNY SKIES
The Getty Center's on-site weather station monitors the climate conditions around the property and relays information to the Grounds Department, which utilizes the data to regulate water use.

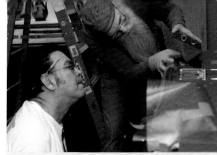

INSTALLATION WIZARDS
The Getty employs twenty-three full-time preparators, who are specially trained to handle and install works of art and ready galleries for exhibitions.

WE DO WINDOWS
Just one of the many responsibilities of the Facilities department is the upkeep and maintenance of the Getty sites, including the big task of window washing.

INTERNAL POST OFFICE
All mail received at the Getty is screened by a logistics technician before being delivered to recipients.

FILMS ON ART

The Getty commissions films to accompany some exhibitions. These movies may be shot on location, as shown here at the Holy Monastery of Saint Catherine, Sinai, Egypt, to bring an added dimension to the visitor experience.

EMERGENCY PREPAREDNESS

All Getty staff must attend emergency training seminars and drills in anticipation of a catastrophic event. Both the Center and the Villa maintain ample supplies in case of a disaster.

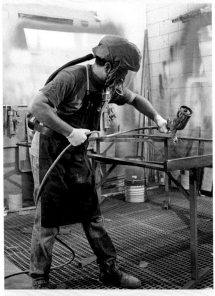

ART SHOPS

Both the Center and Villa have fully equipped shops for woodworking, mount making, framing, and painting.

OFFICE SPACE

Cubicles at the Center adhere to Richard Meier's thirty-inch working grid.

VILLA SCHOLARS

Research Institute scholars utilize the resources in the Villa's Research Library, located in J. Paul Getty's old residence, the Ranch House.

ELEVATOR CALL

The Otis Elevator Company has maintenance staff on-site to oversee the Getty Center's thirty-seven elevators and the tram.

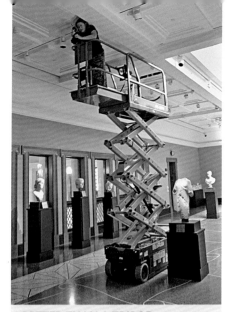

BETTER THAN A TRIPOD

The Imaging Services Department includes both photographers and image technicians. Here, a staff photographer shoots an ancient sculpture in the Villa galleries.

BANNERS

Street banners, which promote Museum exhibitions throughout the city, are designed by the Museum's Exhibition Design Department, printed at an off-site location, and checked for quality by production coordinators in the Publications Department.

WEB GROUP

The Getty's Web team of fourteen designs and produces the contents of the Getty's Web site, www.getty.edu.

FOUR-LEGGED SECURITY OFFICER

Stationed at the Center's south service entrance, members of the Getty's elite canine unit are trained to look for potentially dangerous materials, and even wear a blue staff ID badge.

ART IS EVERYWHERE

Playful handmade signs alert staff to the ubiquity of art. Works might be in laboratories, imaging stations, or study and collection areas.

OUR OWN AMAZON.COM
The Publications warehouse in Van Nuys fulfills Getty-originated book and merchandise orders from merchants and individuals around the world.

INFORMATION CENTER
The Getty Conservation Institute's Information Center provides an integral resource for the conservation community.

MARATHON OF BOOKS
The Research Institute is continually acquiring books for its library and special collections.

KEEPING THE GETTY GREEN
The Grounds Department at the Center prepares to lay down turf on the lawn between the Exhibitions Pavilion and the Central Garden.

EXHIBITIONS FOR MICE
The Museum employs eleven exhibition designers who devise and produce the often-complex designs for Museum shows. The planning usually begins with a miniature model of the artworks in the galleries.

ANCIENT COOKERY
The Villa offers occasional culinary workshops that pair food with themes about art.

CAUTION: SCIENTISTS AT WORK
A Conservation Institute scientist prepares a sample to be analyzed in one of the Institute's laboratories.

HANDLE WITH CARE
A work of art is packed, crated, and sent off to its next destination.

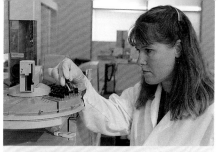

FIELD TRIP TO ANTIQUITY
The Villa hosts hundreds of school groups each year.

SOUND CHECK
An engineer supervises a performance from the sound booth in the Harold M. Williams Auditorium at the Center.

TABLE FOR TWO THOUSAND, PLEASE
Bon Appétit Management Company, which runs the Getty's food operations, feeds more than two thousand people a day at the Center.

THE LAST TRAM
Good night, *Irises*. Good night, *Still Life with Apples*. Good night, *Armorial Plate with the Flaying of Marsyas*. Good night, *Gandydancer's Dream*...

ACKNOWLEDGMENTS

When I was handed the task of creating a "guide to the Getty," I was perplexed. Our two campuses are huge, many of their buildings closed to the public, and their surrounding parkland not easily explored. Moreover, maps, guides, handbooks, and brochures are plentifully available and regularly updated. So, what to do?

The answer, once conceived, seemed obvious and even fun: show our visitors, and our potential visitors, what they cannot normally see—scientists in their laboratories; librarians cataloguing their books; armies of conservators, mount makers, curators, designers, and art handlers setting up an exhibition; and even goats munching chaparral to help prevent brush fires—that is, take everyone on a trip they simply cannot arrange for themselves, and while doing so, explain to them what we all do here in the service of the mission that our President, James Wood, so clearly describes in his foreword.

To accomplish this, a photographer and a publications person had to disturb all these people—and yes, goats, too—by barging into their offices and laboratories (and pens), prying into their work, and flashing lights in their faces. We are both grateful for their equanimity and in awe of their skill. We also thank the program directors—Michael Brand, Thomas Gaehtgens, Deborah Marrow, and Timothy Whalen—and their associates for first submitting to our interviews and then so thoroughly and sensitively reviewing the text and illustrations.

Richard Ross was commissioned to take the special photography we required, and when, inevitably, we found ourselves in need of more pictures long after he had completed his work, the photographic staffs and archivists at the Museum, the Foundation, and the Research and Conservation institutes stepped in. The beauty of the illustrations and the visual drama of, say, a storeroom or a test tube are due to the artistry of Richard and of our own photographers.

My last words, of course, must be to William Hackman, who wrote the text, and to the Getty Publications team, who, with skill, imagination, and enthusiasm, breathed life into this little book. Editor Patrick Pardo shaped this book with a sculptor's hands. Copyeditors Gregory Dobie and David McCormick corrected and polished the text. Elizabeth Zozom exercised a preternatural patience in laying out a complex production schedule—more than once! Most especially, Jim Drobka designed a book whose every page delights, surprises, and makes sense, while Elizabeth Kahn—who knows where every existing picture of the Getty resides—with the assistance of Karen Shields searched and searched again for just the right picture: they made it happen.

All of these people have given us a book that, we hope, reflects the excitement of the Getty adventure. It is an experience we are delighted to share with you.

Mark Greenberg
Editor in Chief
Getty Publications

ILLUSTRATION CREDITS

Neville Agnew: p. 125B

David Albanese: p. 157TR (work shown: ©John Baldessari 2000)

Guillermo Aldana: pp. 124, 125T

Lori Anglin: p. 123

Eleanor Antin: p. 113ML, Courtesy of Eleanor Antin

Bart Bartholomew: pp. 52, 93T

Jane Bassett: p. 117M, Courtesy of Bayerishes Nationalmuseum, Munich

Jobe Benjamin: pp. 104T, 104–105B

Marina Berlozerskaya: p. 10T

Tom Bonner: p. 50B

Gilbert Borreul: p. 174MR

Elsa Bourguignon: p. 122

Paula Carlson: p. 174TR

Nicole Cohen: p. 156B (work shown: ©Nicole Cohen)

Christopher Coniglio: p. 174BL

Brian Considine: pp. 151BL (work shown: ©2008 Artists Rights Society [ARS], New York /ADAGP, Paris), 151BR (work shown: ©2008 Artists Rights Society [ARS], New York /ADAGP /FAAG, Paris)

Corbis: p. 4TL (©Bettmann /CORBIS), 4TM (©Hulton-Deutsch Collection /CORBIS), 4BR (©Bettmann /CORBIS)

Tahnee Cracchiola: pp. 18T, 145T, 146, 148 (work shown: ©Inge Manzù), 149T (work shown: Courtesy of Mark di Suvero and Spacetime C.C.), 149B (work shown: ©Ellsworth Kelly), 150 (works shown: L, ©2008 Artists Rights Society [ARS], New York /ADAGP, Paris; M, ©2008 C. Herscovici, London / Artists Rights Society [ARS], New York; R, Reproduced by Permission of the Henry Moore Foundation), 164B, 166T, 167B, 175BR, 176ML

Jim Drobka: pp. 88B, 140TL, 163T

Patrick Frederickson: p. 88MB

Juan M. Garcia: p. 163M

Getty Imaging Services: pp. 61T, 64, 68B, 70T, 73R, 74T, 75T (David Hockney, Pearblossom Hwy., 11–18th April, #2, 1986 [second version], 1986, photographic collage, 71½ x 107 in., ©David Hockney)

Getty Research Institute, Visual Media Services: p. x, 840006; p. 4TR, Hewins 1986.IA.10-4; p. 4ML, 1992.IA.3-1; p. 5TL, 2004.R.10, photograph by Julius Shulman; p. 5M, Hewins 1986.IA.10-4; p. 5B, Hewins 1986.IA.10-6; p. 8T, 1987.IA.15; p. 8M, 2006.IA.22, Box 1; p. 8B, 2006.IA.22, Box 4; p. 9, 1997.IA.10; p. 10L, 1987.IA.24, Board 121; p. 11T, 1987.IA.24; p. 11B, 1987.IA.24, Board 147; p. 12T, 2006.IA.22, Box 5; p. 14,

2004.IA.06, illustration by Max Driven; p. 17ML, 1987.IA.24; p. 24, 1997.IA.10, Box 20, Binder 7, The Benjamin and Gladys Thomas Air Photo Archives, Spence Collection, UCLA Department of Geography; p. 25M, 1997.IA.10, Box 71, photograph by Joe Deal; p. 26, 1997.IA.10-52; p. 27A, 1997.IA.10-74; p. 28, 1997.IA.10-60, photograph by Tom Bonner; p. 29TL, 29TR, 1997.IA.10-60; p. 29ML, 1997.IA.10-39; p. 29MR, 1997.IA.10-60, photograph by Grant Mudford; p. 29B, 2003.IA.08-1, photograph by Jock Pottle/Esto; p. 30, 1997.IA.10-39, photograph by Stephen Rountree; p. 31A, 2003.IA.08-1, photograph by Jock Pottle/Esto; p. 32, 1997.IA.10-74; p. 33TL, 1997.IA.10-39; p. 33TR, 1997.IA.10-61; p. 34B, 35T, 1997.IA.10-63, photographs by Stephen Rountree; p. 35M, 1997.IA.10-63, photograph by Vladimir Lange; pp. 36–37, 1997.IA.10-22, photograph by Vladimir Lange; pp. 38–39T, 1997.IA.10-65, photograph by Dennis Keeley; p. 38B, 1997.IA.10, photograph by Howard Smith; p. 39B, 1997.IA.10-69, photograph by Joe Deal; p. 41TR, 1997.IA.10-19, photograph by Vladimir Lange; p. 42A, 1997.IA.10-22, Binder 13, photograph by Vladimir Lange; pp. 44–45A, 1997.IA.10-27, photographs by Linda Warren; pp. 46–47A, 1997.IA.10-66, photographs by Bruce Bourassa; p. 48A, 1997.IA.10, Box 68, 48TL photographs by Robert Irwin, 48MR photograph by Tom Bonner; p. 49A, 1997.IA.10, Box 68, photographs by Dennis Keeley; p. 50ML, 1997.IA.10-22, photograph by Vladimir Lange; p. 51TL, 1997.IA.10-44, photograph by Robert Pacheco; p. 51TR, 1997.IA.10, photograph by Vladimir Lange; p. 98; p. 99T (work shown: ©2008 Artists Rights Society [ARS], New York /ADAGP, Paris /Succession Marcel Duchamp); p. 99B, photograph by Julian Shulman; p. 100A; p. 101T, photograph by Robert Cassoly; p. 101B, (work shown: ©Coop Himmelb[l]au, photograph by Tom Bonner)

Andy Goldsworthy: p. 157TL (work shown: ©Andy Goldsworthy)

Ronny Jacques: p. 2

Dennis Keeley: pp. 175TR, 176TL

John Kiffe: pp. 105T, 107

Peter Kirby: p. 173TL

Tony Labat: p. 113BL, Courtesy of Tony Labat and Gallery Paule Anglim

Mark Leonard: p. 81T

Longue Vue House and Gardens: p. 133B, Courtesy of Longue Vue House and Gardens

Los Angeles County Museum of Art: p. 133T, Courtesy of the Los Angeles County Museum of Art

Craig Matthew: p. 92B

Ryan Miller / Capture Imaging: p. 82L

Naveen Molloy: p. 83T

Motor Racing Magazine: p. 4MR

Patrick Pardo: p. 175TL

People magazine: p. 5TR, ©2008 Time Inc. All rights reserved

Kira Perov: p. 113MR, Courtesy of Nancy Buchanan

Chris Petrakis: p. 173ML

Francesca Piqué: p. 127T

Brenda Podemski: pp. 140MR, 140BR, 161MR

Patti Podesta: p. 113BR, Courtesy of Patti Podesta

Pontificio Santuario Scala Santa: p. 131, Courtesy of Pontificio Santuario Scala Santa, Rome

Ellen Rosenbery: pp. 7, 17T, 17MR, 18M, 19T, 20B, 22–23A, 80T, 144–145B, 147, 152, 158B, 164T, 165A, 167R, 168–69B, 171MR, 172TR, 173MR

Jack Ross: pp. 41BL, 51B, 63A, 65, 83B, 86T (with Anthony Peres), 88T, 88MT, 89TL, 89MTL, 89MBL, 89BL, 89MR, 90–91A, 129M, 156T (with Christopher Foster and Anthony Peres; work shown ©Bill Viola), 161B, 162T, 171ML, 171BR, 172MR, 172BL, 172BR, 173BL, 173BR, 175MR, 175BL, 176TR, 176MR, 176BL

Richard Ross, ©Richard Ross: half-title page A, title page T, back cover; pp. viii–iv A (works shown: BL, BR, Reproduced by Permission of the Henry Moore Foundation; M, ©2008 Artists Rights Society [ARS], New York /ADAGP, Paris), 15A, 16, 18B, 19B, 20–21T, 34T, 35BR, 40, 41TL, 41BR, 43B, 54–55T, 54–55M, 54–55B (work shown: ©2008 Artists Rights Sociey [ARS], New York /ADAGP, Paris), 56, 57A, 58–59B, 60–61B, 66–67, 68T, 69A, 71, 72, 73L, 74–75B, 76T, 76MR, 77A, 78–79, 80B, 81B, 89TR, 89BR, 94–95T, 94–95M, 96, 97, 102–103, 106, 108, 109A, 110–111A, 112–113T, 114, 115, 116, 117T, 117B, 118, 119L, 120–121A, 128, 129T, 134, 136, 137T, 138, 139, 140ML, 140BL, 142A, 143, 151T (R, ©2008 Calder Foundation, New York /Artists Rights Sociey [ARS], New York), 153, 154T (work shown: ©Alexis Smith), 155 (work shown: ©Ed Ruscha), 158T, 160, 161T, 161MT, 162B, 166B, 168–69T, 168–69M, 170, 171T, 172TL, 173TR, 174BR, 175ML, 176RR

Elon Schoenholz: pp. 92T, 93B

Julius Shulman: title page B, pp. vii, 12M, 59T, 94–95B

Stanley Smith: pp. vi, 25T

Laurie Steiner-Halpern: p. 132

Stacey Rain Strickler: front cover, pp. 141, 159

University of Southern California, Specialized Libraries & Archival Collections: p. 10BR

Rebecca Vera-Martinez: pp. 70B, 84–85B (work shown: Andrea Nasher Collection, ©2000 Tim Hawkinson), 87A, 157B (work shown ©2007 Tim Hawkinson)

Gerard Vuilleumier: pp. 82R, 85T, 86B, 174TL

Linda Warren: p. 6

Lillian Elaine Wilson: pp. 135, 137B, 154B (work shown: ©Martin Puryear)

Lorinda Wong: p. 127B

J. Zastoupil: p. 126A

Artists

Maki Ishii Sowash, violin
After receiving her studies from the San Francisco of Music and the Juilliard School, Maki went on to study with Felix Ayo in Rome, Italy, where she earned a diploma in chamber music from the Accadimia Nazionale Musicale di Santa Cecilia. She has performed in solo and chamber music engagements throughout Italy, Spain, the U.S. and her native Japan. She has also been a member of the San Francisco Opera Orchestra since 1990. Today, she makes her home in San Francisco with her husband, Stephan whom she met at the Opera.

Yukio Sakai, oboe
Yukio began studying the oboe at the age of 19 while in college in Nagoya, Japan. Though he chose not to pursue the oboe as a professional career, the artistic muse has always been with him. Dedicating his time away from work to music, he has served as the principal oboist of the orchestra Ensemble Humanite in Tokyo for over 20 years. He has performed solo concertos with artists such as violinist Felix Ayo and Hansjorg Schellenberger, the former principal oboist of the Berlin Philharmonic. Yukio hopes to share his love of music with his new audience in America.

Motoko Morita, piano
Motoko received her Bachelor's Degree from the Tokyo College of Music, and a diploma in chamber music from Accademia Hipponiana in Vibo Valencia, Italy. Her teachers include Mie Matsuoka on the piano and Teresa Garratti on the harpsichord. She has performed in concerts throughout Japan, including appearances with such renowned artists as oboist Hansjorg Schellenberger and violinist Felix Ayo of I Musici. She lives in Yamanashi, Japan with her husband, a professor of astrophysics, and her two children.

Aya Sakai and Atsuko Sanada, piano
Since graduating from the Tokyo College of Music, **Aya Sakai** has been continuing her studies with Mie Matsuoka amidst her busy schedule teaching and performing in Japan.
Atsuko Sanada has also flourished under Matsuoka's tutelage after obtaining her degree from the Toho College of Music and Drama. She enjoys teaching and performing with various local ensembles in Tokyo. Both credit their success to their families, Aya to her loving parents and grandmother, Atsuko to her husband and her three children. The two are thrilled to return to the U.S. as they embark on a new decade of their collaboration as a piano duo.

Support Staff